D1477103

Serbia and Byzantium

# STUDIEN UND TEXTE ZUR BYZANTINISTIK

Herausgegeben von Claudia Sode

Band 8

Mabi Angar / Claudia Sode (eds.)

# Serbia and Byzantium

Proceedings of the
International Conference
Held on 15 December 2008
at the University of Cologne

**Bibliographic Information published by the Deutsche Nationalbibliothek**

The Deutsche Nationalbibliothek lists this publication in the Deutsche Nationalbibliografie; detailed bibliographic data is available in the internet at http://dnb.d-nb.de.

**Library of Congress Cataloging-in-Publication Data**

Serbia and Byzantium : proceedings of the international conference held on 15 December 2008 at the University of Cologne / Mabi Angar, Claudia Sode (eds.).
    pages cm. -- (Studien und Texte zur Byzantinistik, ISSN 0944-7709 ; Band 8)
  Includes bibliographical references.
  ISBN 978-3-631-58781-2 -- ISBN 978-3-653-04027-2 (e-book) 1. Serbia--Relations--Byzantine Empire--Congresses 2. Byzantine Empire--Relations--Serbia--Congresses. 3. Serbia--Civilization--Congresses. 4. Byzantine Empire--Civilization--Congresses 5. Intercultural communication--Serbia--History--To 1500--Congresses. 6. Intercultural communication--Byzantine Empire--History--To 1500--Congresses. 7. Serbia--Antiquities--Congresses 8. Byzantine Empire--Antiquities--Congresses I. Angar, Mabi, 1975- II. Sode, Claudia.
  DF547.S4S47 2013
  949.71--dc23

                                                        2013043612

ISSN 0944-7709
ISBN 978-3-631-58781-2 (Print)
E-ISBN 978-3-653-04027-2 (E-Book)
DOI 10.3726/978-3-653-04027-2

© Peter Lang GmbH
Internationaler Verlag der Wissenschaften
Frankfurt am Main 2013

www.peterlang.com

# Preface

From the 12th century onwards, relations between the Byzantine Empire and the major rising power in the Balkans, the Serbian Kingdom, underwent many changes – oscillating from the extreme of downright aggression to efforts of peaceful co-existence and collaboration often against their common opponents such as the Bulgarians. At the same time, other parties like Venice, the Crusaders, and the Holy See pursued their own economic, strategic or political interests in the region. Serbian-Byzantine interaction was thus multi-fold, complex and in many regards was less of a dichotomy than is suggested by the title of the international conference "Serbien und Byzanz / Serbia and Byzantium" held on 15 December 2008 at the University of Cologne. The conference intended to buttress and highlight long-established relations between the two faculties of Philosophy of Cologne University and Belgrade University. Colleagues from Serbia, Turkey and the USA accepted our invitation and provided new perspectives on Serbian-Byzantine relations, questioning established scholarly opinions, raising important methodological concerns and embedding the two medieval powers in a broader political, economic and socio-religious landscape. We are grateful for their contributions and for their patience with the publication of the present volume. The papers in this volume cover a wide range of themes related to interdependencies between Serbia and the Byzantine world.

In his contribution "Architecture in Byzantium, Serbia and the Balkans through the Lenses of Modern Historiography," *Slobodan Ćurčić* demonstrates the impact of single, yet highly authoritative scholars such as the archaeologist and historian Gabriel Millet on the field of architectural history and argues for the urgent need for new approaches in the study of the architecture of the Balkans beyond ideological and nationalistic agendas.

By examining the internal and external political as well as ecclesiastical situation of Medieval Serbia during the 12th and early 13th centuries and the animosities between the Archbishoprics of Ohrid and Ras, *Jelena Erdeljan* challenges the widely accepted notion of Stefan Nemanja's church of the Virgin at Studenica as having been intentionally planned as a burial site for the Nemanid ruler. Her re-reading of the sources provides arguments for an interpretation of Studenica as a powerful statement of Orthodoxy which

only later became imbued with dynastic associations and thus became a memorial of the Serbian Kingdom.

*Vujadin Ivanišević's* paper sheds light on the iconographic relationship between medieval Serbian coinage, minted from the first third of the 13th century onwards, and its possible Byzantine and Western European prototypes, indicating at the same time the influence of economic circumstances as well as the circulation of specific coinages, which led to an orientation towards the one or the other monetary system.

The contribution of *Čedomila Marinković*, based on her book *Slika podignute crkve* (Image of the Completed Church, 2007), explores the complex relationship between the painted models of churches in Serbian donor portraits and the actual churches which are depicted. She analyses the non-illusionistic visual strategies used by medieval artists to create a 'realistic' image of a given church and argues that the representations of churches in the donor portraits are depictions of the actual, finished buildings, intended not least to legally substantiate the endowment made by the donor.

Finally, *Vlada Stanković* analyses diplomatic relations between Byzantines and Serbs and indicates the impact and burden of nationalistically hued Serbian scholarship. He argues for the need to re-evaluate Serbian and Byzantine sources from a philological, literary and historical point of view and to consider new archaeological evidence, instead of relying on a fixed corpus of alleged 'facts' established during the early 20th century and repeated ever since. His contribution may eventually be read as the outline of a program for further research on Serbian medieval history: he suggests focusing scholarly attention on questions of ideological, political and cultural appropriation and interdependencies between Serbia and Byzantium, and stresses the importance of micro-historic in-depth studies.

The conference "Serbia and Byzantium" would not have been possible without the support of several institutions. We would like to thank the Zentrum für Mittelalterstudien (ZEMAK) and the Zentrum Osteuropa (ZOE) at the University of Cologne for their generous financial contribution. The Consulate General of the Republic of Serbia in Düsseldorf kindly provided a festive reception. The printing of this volume was co-financed by the Zentrum Osteuropa (ZOE) and the Claus-von-Kotze-Stiftung of the University of Cologne. Special thanks go to Andreas Fliedner for editorial help.

Cologne, August 2013

Mabi Angar                                    Claudia Sode

# Contents

# Architecture in Byzantium, Serbia and the Balkans Through the Lenses of Modern Historiography

*Slobodan Ćurčić*

The Balkan countries share a rich architectural heritage, but have produced no adequate historiography that would account for its existence internationally speaking, or affirm its historical significance on a broader regional scale.[1] In a climate of profound political and national divisiveness, the twenty-first century in the Balkans has been inaugurated with a list of national states grown to ten, while the process of fragmentation continues unabated, having lost little of the momentum with which it began in the early 1990s. Under these conditions, the possibility of grasping a larger, regional picture, as far as the architectural heritage is concerned, has become more difficult than ever, while the proliferation of studies focused on distinctive 'national' characteristics of architectural heritage on the territories of the new states is on the rise with alarming implications. The desired broader historical and cultural picture appears to be fading despite all expectations and hopes. While within the Balkans this situation may be perceived as less alarming and may even not be so noticeable, in a wider international perspective this does have major negative implications. Non-native scholars, who may be inclined to address various specific issues pertaining to the Balkans, face a variety of obstacles, the chief among which is the lack of a coherent regional historical perspective that would facilitate the understanding of various problems within appropriate historical frameworks devoid of modern nationalist objectives and constraints. As scholars, we must register numerous new phenomena, whose effects, individually and collectively, are taking us farther and farther from being able to grasp the larger relevant picture with its own historical merits, nuanced developments and unique achievements. Instead, energies seem to be invested in proving different 'historical truths' to rapidly shrinking audiences with polarized views, while the larger far more relevant issues that bespeak *real* cultural contributions are becoming increasingly more scarce and are being all-too-easily dismissed as irrelevant. Furthermore, ambitions in the context of the historiography of architecture reach beyond the current state borders *only* when seeking to rectify 'historiographical injustices' –

---

1   S. Ćurčić, *Architecture in the Balkans from Diocletian to Süleyman the Magnificent (ca. 300 – ca. 1550)* (London and New Haven, 2009) aims at setting the stage for new research directions in the region.

commonly through willful, undocumented revisionist enterprises.[2] Occasional efforts by professional historians to counter the growing presence of such phenomena are invariably drowned out by the sheer volume of publications commonly produced by enthusiastic amateurs whose work is facilitated by a mushrooming publishing industry, itself driven exclusively by profit concerns.

The problem, as I have outlined it, has pan-Balkan implications, but my task here, though couched within the same framework, will be considerably narrower. The purpose of this paper is to explore the emergence and the relationship of modern historiographies as they pertain to the architectural traditions of Byzantium and medieval Serbia within the general Balkan framework. The historiographical traditions in question have essentially common roots with parallel developments, followed by the generally diverging patterns of growth evident over time. While, historically speaking, there can be no doubt that differences in the development of architectural traditions in Byzantium and in Serbia did exist, the interpretation of the phenomena in the two contexts has often been deprived of sound exploration of issues within a broader research framework. Whatever the specific conditions at any given moment of the historiographical enterprises may have been, the general results frequently fell short of fully explaining either the phenomena in question, or the circumstances that led to their occurrence, or – most commonly – both.

## I.  Origins of Modern Historiographical Tradition in the Balkans

Although the beginnings of scholarly studies of medieval architecture in the Balkans have their roots in the nineteenth century, the critical developments actually took place in the years leading up to and immediately following World War I. In my opinion, it is in the context of what transpired between ca. 1900 and 1920 that clues for some of the trends that still bedevil scholarship must be sought. During the two mentioned critical decades at the beginning of the twentieth century, a number of important general books dealing with medieval architecture in the Balkans appeared, all of them authored by non-native, predominantly western scholars. Behind the scholarly goals of some of these works, as I have tried to suggest elsewhere, lurked also intentions of appealing to the cur-

---

2   N. Tuleshkov, *Arkhitekturnoto izkustvo na starite B'lgari* (Architectural Art of the Old Bulgarians), *I. Srednovekovie* (The Middle Ages) (Sofia, 2001), is but one, albeit drastic example of such phenomena. The author essentially argues that Serbia had no architecture of its own during the medieval period. Instead, he sees its architectural tradition as a fusion of Croatian and Bulgarian inputs, while completely ignoring the Byzantine role in the shaping of larger regional developments in the Balkans, and of Bulgaria in particular.

rent political sentiments in different Balkan states in hopes of securing their po-
litical and military alliances and collaboration on the eve of and during World
War I.[3] Scholarly intentions, therefore, not uncommonly became blurred with
the 'glorification' of one or another national group, thus pandering to various
nascent nationalist sentiments. Notable, though not alone in this regard, was the
input of the distinguished French scholar Gabriel Millet (1867-1953).[4] A graphic
manifestation of this attitude may be gleaned from a French war-time propagan-
da booklet entitled *La Serbie glorieuse* that contains Millet's long essay under
the heading "L'ancien art serbe" published in 1917, two years before his capital
work on Serbian medieval architecture bearing the same title made its appear-
ance (Fig. 1). Emblazoned with the Serbian coat of arms, the publication unmis-
takably reveals its unstated function. Parenthetically speaking, it is of interest to
point out that precisely the same strategy was employed in 1985 in a German
publication devoted to medieval architecture of Albania (Fig. 2). Prepared as a
catalogue of a photographic exposition on the monuments of medieval Albania,
its text was written by a German classicist art historian, Guntram Koch, while its
cover employed the Albanian flag with its coat of arms, in a manner reminiscent
of Millet's publication of nearly seven decades earlier. While the objectives that
occasioned the two publications obviously differed, the strategy they employed
was identical.

Returning to Gabriel Millet, his *curriculum vitae* reveals that he was travel-
ing, photographing and gathering information in Greece already from the 1880s
and in other parts of the Balkans from around 1900 on (Fig. 3).[5] Very produc-
tive, he authored a number of books of seminal importance for the development
of scholarship in these areas. In 1916, Millet published his doctoral dissertation
entitled *L'École grecque dans l'architecture Byzantine*. Borrowing from the his-
toriographical tradition on French medieval architecture, he introduced the con-
cept of *schools* into the study of Byzantine architecture. In his book, Millet iden-

3    S. Ćurčić, "Architecture in the Age of Insecurity. An Introduction to Secular Architecture
in the Balkans, 1300-1500," *Secular Medieval Architecture in the Balkans, 1300-1500,
and Its Preservation*, eds. S. Ćurčić and E. Hadjitryphonos (Thessaloniki, 1997), pp. 19-
51, esp. pp. 24-26.

4    M. C. Lepage, "Gabriel Millet, Esprit élégant et moderne," *Hommage rendu à Gabriel
Millet et André Grabar, Séance du 28 octobre 2005. Institut de France. Académie des
Inscriptions et Belles-Lettres* (Paris, 2005), pp. 5-18.

5    W. E. Kleinbauer, "Prolegomena to a Historiography of Early Christian and Byzantine
Architecture," *Early Christian and Byzantine Architecture. An Annotated Bibliography
and Historiography* (Boston, 1992), esp. pp. xil-lx; also D. Couson-Desremaux, "Gabriel
Millet," *Niš i Vizantija. Četvrti naučni skup, Zbornik Radova*, IV (2006), pp. 29-58.

tified two major independent "schools" of Byzantine architecture – "the School of Constantinople" and "the Greek School".[6] This was followed in 1919 by *L'ancien art serbe: Les églises*, a book devoted to the study of medieval architecture in Serbia, which Millet subdivided into three schools – "the Raška School", "the School of "Byzantinized Serbia" and "the Morava School".[7] Both of Millet's books found fertile soil in the subsequent historiography on architecture within Greece and within Serbia. In both cases Millet, perceived as an 'impartial' foreign scholar of impeccable authority, ultimately became an undeclared idealized champion of national causes in architectural studies. In the years after World War I, as a new political map of the Balkans evolved, Millet's 'system' assumed additional practical aspects in the national states now within their newly established boundaries. In Greece, Millet's idea of the "Greek School" became a cornerstone of national scholarship and has remained so ever since. Over the years, his idea has undergone some fine-tuning, though without significant substantive changes. The term "Greek School" was first modified into the "Hellenic School" and, more recently, into the concept of the "Helladic School". The latter name, based on that of the Byzantine theme of Hellas but also used in modern Greek as the name of the state, has been introduced with an interesting justification.[8] In essence, Millet's central idea of the 'school' has been allowed to stand without adequate critical re-evaluation of the concept and its broader implications.

---

6  G. Millet, *L'École grecque dans l'architecture byzantine* (Paris, 1916). For a brief account of Millet's contribution to the study of Byzantine architecture see Kleinbauer, "Prolegomena" (see fn. 5), pp. lix-lx.

7  G. Millet, *L'ancien art serbe: Les églises* (Paris, 1919). His classification system was undoubtedly inspired by that introduced thirteen years earlier by the Russian architect and architectural historian P. P. Pokryshkin, *Pravoslavnaia tserkovnaia arkhitektura XII-XVIII stol. v nynieshnem Serbskom korolevstvie* (St. Petersburg, 1906), who was using the term "group" instead of "school", introduced by Millet.

8  P. Vocotopoulos, "Church Architecture in Greece during the Middle Byzantine Period," *Perceptions of Byzantium and Its Neighbors (843-1204)*, ed. O. Z. Pevny (New York, 2000), pp. 154-167, esp. fn. 1: "I prefer the term 'Helladic School' rather than the current 'Greek School', which sometimes has been misinterpreted as referring to a national Greek school, thereby implying that the buildings of other regions, such as Constantinople and its hinterland, Thessalonike or Epiros, were not built by Greeks."

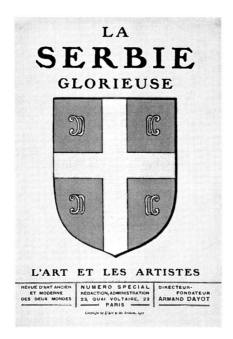

Fig. 1: Book cover: G. Millet, La Serbie
glorieuse (Paris, 1917)

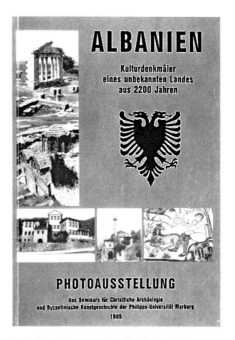

Fig. 2: Book cover: G. Koch, Albanien.
Kunstdenkmäler eines unbekannten
Landes (Marburg, 1985)

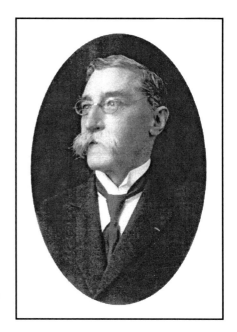

Fig. 3: Gabriel Millet (ca. 1910)
(from: Hommage rendu à Gabriel
Millet et André Grabar (Paris, 2005)

*Fig. 4: Book cover: M. M. Vasić, Žiča i Lazarica (Belgrade, 1928)*

*Fig. 5: Book cover: A. Deroko, Monumentalna i dekorativna arhitektura (Belgrade, 1953)*

## II.     Beginnings of Modern Historiographical Tradition in Serbia

A similar situation, and for precisely the same reasons, has evolved in Serbia, where Millet's notion of 'schools' became the foundation of native, Serbian scholarship. Unlike in Greece, where general books on national medieval architecture written by native scholars emerged only after World War II, the first major attempt along these lines in Serbia was authored eighty years ago by Miloje M. Vasić. In a sense disguised by its very title, *Žiča and Lazarica. Studies in Serbian art of the Middle Ages* was published in 1928, and, it would seem, was the first serious effort at defining the parameters of 'national' architecture of medieval Serbia (Fig. 4).⁹ Vasić, who went on to become an internationally known scholar for his work in the realm of pre-historic archaeology, in *Žiča and Lazarica* made an early effort to isolate the Serbian architectural tradition from that of Byzantium by excluding *entirely* what Millet had defined as the "School of Byzantinized Serbia" from his consideration. Needless to say, the attempt revealed major intrinsic weaknesses, compelling Vasić to include the ultimately 'unavoidable' key monuments of Byzantine architecture, such as the Katholikon of the Serbian Hilandar Monastery on Mount Athos. Vasić's otherwise solid work, for reasons that are not entirely clear, has remained substantially out of the limelight in the later studies of Serbian medieval architecture. Whatever Vasić's own motives may have been, it is obvious that he took the cue from Millet's conceptual thinking by sharpening the definition of the national parameters of Serbian medieval architecture, thus going in the same direction, but well beyond Millet's stated intentions. Serbian scholars of the following generation, notably the architect Aleksandar Deroko, adhered more closely to Millet's concept of 'schools'. In his book, *Monumental and Decorative Architecture in Medieval Serbia*, first published in 1953, Deroko followed Millet's principles of organization of the material, but employed the term "group" instead of "school" (Fig. 5).¹⁰ Envisioned as a textbook for university courses in the history of Serbian medieval architecture, Deroko's book has, since its initial publication in 1953, gone through several re-publications, becoming the standard work on the subject also in scholarly contexts. Thus, Millet's notion of schools has become fully sanctioned, retaining its place in the studies of Serbian medieval architec-

---

9   M. M. Vasić, *Žiča i Lazarica. Studije iz srpske umetnosti srednjeg veka* (Belgrade, 1928).

10  A. Deroko, *Monumentalna i dekorativna arhitektura u srednjovekovnoj Srbiji* (Eng. sum.: "Monumental and Decorative Architecture in Medieval Serbia") (Belgrade, 1953; 2nd ed. 1962). In this popular book Millet's concept was modified only slightly – the term "group" replaced that of "school" (probably following Pokryshkin), while "Byzantinized Serbia" was subdivided further into two sub-groups – those of Kosovo and Macedonia.

ture despite occasional isolated attempts to demonstrate its various inadequa-
cies.[11] Owing to the combined legacy of Millet's book followed by the one by
Deroko, we can conclude that for three successive generations the notions ex-
pressed by the French scholar have informed the manner of looking at and the
thinking about the medieval architectural heritage of Serbia. Those affected by
Millet's ideas included not only Serbian, but also distinguished western scholars
as Richard Krautheimer and Cyril Mango. Both Krautheimer and Mango,
though not the first to do so, treated the architecture of medieval Serbia as a sep-
arate, essentially national sub-division of Late Byzantine architecture in their
comprehensive surveys of Byzantine architecture, initially published in 1965
and 1976, respectively. Both acknowledge their dependence on Millet as their
basic source of information and ideas for Serbia.[12] Mango is particularly explicit
in praising Millet's contribution: "The basic classification of Serbian churches
was established by Gabriel Millet and has remained valid to this day."[13]

Only in exceptional cases has Serbian medieval architecture been analyzed
by Serbian scholars within the larger, Byzantine context. But even when this did
occur, as in the case of the book published in 1998 by Vojislav Korać and Mari-
ca Šuput, Serbian medieval architecture was analyzed as an independent entity
within separate, more general chapters, clearly following Mango's conceptual
model and, ultimately, the entrenched principle initially laid down by Gabriel
Millet eighty years earlier.[14] Millet's ideas, enthusiastically promoted by the first
generation of Serbian scholars after the end of World War I, for all practical
purposes, became the unassailable foundation upon which the study of Serbian
medieval architecture has been resting ever since.

In the 1930s, and even more rigorously so after the end of World War II, the
study of Serbian medieval architecture turned towards the study of individual

11   S. Ćurčić, "The Significance and Sources of the 'Morava School' Architecture," *Sum-
     maries of Communications, 18th International Congress of Byzantine Studies*, I (Mos-
     cow, 1991), p. 258. A major effort in that direction now is J. Trkulja, "Articulation of
     Church Façades in Late Byzantine Architecture: the Case of the 'Morava School'", Ph.D.
     Diss., Princeton University (2004), currently being prepared for publication.
12   R. Krautheimer, *Early Christian and Byzantine Architecture* (Baltimore, 1965), pp. 300-
     304 ("Salonica and Serbia"), refers to Millet's *L'ancien art serbe* as "still basic" (fn. 21);
     the assessment was deleted in the 4th edition (1986). C. Mango, *Byzantine Architecture*
     (New York, 1976), pp. 308-323 ("Yugoslavia").
13   Mango's view remained unaltered in the subsequently published editions; cf. Mango,
     *Byzantine Architecture* (paperback, New York, 1985), p. 176.
14   V. Korać and M. Šuput, *Arhitektura vizantijskog sveta* (Architecture of the Byzantine
     World) (Belgrade, 1998). In a slightly different form, the book also appeared in French:
     T. Velmans, V. Korać and M. Šuput, *Rayonnement de Byzance* (Saint-Léger-Vauban and
     Paris, 1999).

buildings. Driven by the intellectual desire to understand the intrinsic properties and characteristics of individual buildings in greater depth, members of this generation were increasingly and characteristically focused on issues related to details as opposed to the 'larger picture'. Scholars belonging to this generation, however, became generally satisfied with uncritical quotations of Gabriel Millet when it came to providing a larger framework of understanding for the individual buildings in question. Thus, the intellectual 'monument' honoring Millet's contribution to the study of Serbian medieval architecture – metaphorically speaking – continued to grow higher and higher, without any efforts to re-examine and test its own foundations.[15]

## III.  Beginnings of Modern Historiographical Tradition in Greece

In the meantime, the course of studies of the history of Byzantine architecture in the Balkans also followed the general guidelines established by Gabriel Millet in 1916.[16] Millet's division of the body of Byzantine architecture in the Balkans into two "schools" – the "School of Constantinople" and the "Greek School" – may have had a greater significance in terms of its prophetic implications relative to the political realities that evolved in the aftermath of World War I than in its intellectual substance. As the Ottoman Empire collapsed, its successor, the national state of Turkey, retained a minimal foothold in the Balkans with the city of Istanbul along with a swath of land constituting the easternmost section of the Byzantine province of Thrace. Following the Greco-Turkish War of 1920-21 and the exchange of populations between Greece and Turkey in 1922, the geopolitical framework of the new national states – Greece and Turkey – became cemented. With this came the issue of the definition of 'national patrimony' with all of its implications within the two new contexts. The component of Byzantine architectural heritage defined by Millet as the "School of Constantinople" found itself substantially on the territory of Turkey, while its counterpart, labeled by him as the "Greek School", appeared predominantly on the territory of what became the modern Greek state. Greek scholars readily embraced this new reality. Relying on the intellectual underpinnings provided by Millet, the "Greek School" under a modified name – as the "Hellenic School" of Byzantine architecture – became a coherent component of Greek national architectural heritage. Scholars such as the archaeologist Georgios Sotiriou and the architect Anastasi-

---

15  C. Grozdanov, "U slavu Gabrijela Mijea" ("To the Glory of Gabriel Millet"), *Niš i Vizantija. Četvrti naučni skup, Zbornik Radova*, IV (2006), pp. 17-27.

16  Millet, *L'École grecque* (see fn. 6).

os Orlandos set out recording and publishing individual monuments.[17] Of particular significance was Orlandos' major contribution entitled *Archaion tôn vyzantinôn mnêmêon tês Ellados*, which was published in installments over four decades, beginning in 1935.[18] A monumental work, the *Archaion* became a major resource for the study of Byzantine architecture. Methodologically speaking it served as the model par excellence, guiding the work of the two following generations of Greek scholars, the active ones among whom still continue to expand our understanding of the rich material on the Greek territory. As important and timely as Orlandos' enterprise was in its day, the methodological paradigm that it provided for his successors may also be thought of as a deterrent of sorts. Focused on the detailed analysis of single buildings or small groups of tightly related monuments, scholars who have devoted their energies to such enterprises have failed to engage in broader debates or to produce major syntheses on Byzantine architecture. In fact, with the exception of some university-level textbooks, the first significant synthesis on Byzantine architecture, territorially limited to Greece, appeared only in 2001. Written by an architect-architectural historian, Charalambos Bouras, *Byzantinê kai Metabyzantinê architektonikê stên Ellada* (Byzantine and Post-Byzantine Architecture in Greece), provides the first serious modern scholarly overview of Byzantine architecture in Greece.[19] On account of the fact that it appeared only in Greek, its international impact has been substantially curtailed. Thus, the state of scholarship in Greece in some sense may be compared with what I have said about Serbia, namely that 'national' architectural heritage is studied primarily on the national scale and apparently for 'national' reasons. Because Greece, among all the modern nations, comes closest to being able to call itself the 'heir' of Byzantium, engagement of Greek scholars with broader Byzantine architectural heritage is glaringly lacking, their interest having been largely focused on the "Hellenic School". It is only most recently that this trend may have started undergoing modification.[20] Byzantine

---

17  For the contributions of Sotiriou and Orlandos, see Kleinbauer, "Prolegomena" (see fn. 5), pp. lii-liv.

18  A. Orlandos, *Archaion tôn byzantinôn mnêmêon tês Ellados* (Archives des monuments byzantins de Grèce), 12 Volumes, 1935-1973. A methodologically comparable, but encyclopedically organized work on medieval architecture in Serbia is V. R. Petković, *Pregled crkvenih spomenika kroz povesnicu srpskog naroda* (Fr. sum.: "Aperçu des monuments réligieux à travers l'histoire Serbe") (Belgrade, 1950).

19  Ch. Bouras, *Byzantinê kai Metabyzantinê architektonikê stên Ellada* (Byzantine and Post-Byzantine Architecture in Greece) (Athens, 2001).

20  Several recent articles by Greek scholars of the middle generation, notably those of Stavros Mamaloukos, Sotiris Voyadjis, et al., point in that direction. Generally limited to single buildings or specific phenomena, these have thus far failed to seriously impact the course of scholarship on a broad scale.

architectural heritage, after all, is found in all parts of the Balkans; hence, looking at buildings only on the territory of a single national state provides a very limited and almost invariably a distorted picture.

The other side of the same coin, 'struck' – we might say – by Gabriel Millet, is the history of modern historiography related to what he labeled the "School of Constantinople". Byzantine architecture of Constantinople by no means can be said to have suffered from scholarly neglect. Nor can it be suggested that it has been 'hijacked' by some modern national interest. Yet, serious problems do exist also in this context, though they are of a very different nature. While the presence of foreign scholars in Istanbul since the era of Kemal Ataturk has been steadily on the rise, their ranks have included representatives exclusively of the western nations. Often operating through established and well-funded research centers, western scholars have generally been able to remain engaged with the Byzantine architecture of Istanbul. This has not been true of other scholars, especially those from countries that, historically speaking, had strong cultural ties with Byzantium. Thus, Greek, Russian, Bulgarian, Serbian, Armenian, and Georgian scholars have generally not been in the position to engage in the study of the history of the city whose past was intimately linked with architectural developments within their own countries. Parenthetically speaking, it should be noted that such a pattern did not exist within the system of the Ottoman Empire. In the context of our topic, the problem is especially glaring. Architecture of the so-called "Constantinopolitan School" beyond the city walls of Constantinople and its close environs remains understudied, largely on account of the mentioned inaccessibility but also because of the lack of interest in such monuments within contexts where they may be perceived as being outside the framework of genuine 'national' heritage. As part of 'non-national' patrimony, theoretically but also practically speaking, any monument may have difficulties being ranked high on the list of priorities within any system harboring exclusive, nationalist agendas. While signs of improvement have appeared within the past decade, their numbers and rate of appearance is still inadequate.

## IV. Further Partitioning of the Historiographical Traditions

A final point in our analysis regarding historiographical developments after ca. 1920 is that, once myopic mechanisms were introduced, the tendency became to narrow the field of vision even further. Though he did not discuss the concept of the "Macedonian School" in relationship to architecture, Millet may also be held accountable for having introduced the term in the context of his study of fresco

painting.[21] In a manner that, objectively speaking, could not have been foreseen by him, the term gained a life of its own, affecting the study of architecture as well.[22]

Within the current analysis of historiographical problems, we must bear in mind that, since the 1920s, very few western scholars have been engaged with Byzantine architecture in the Balkans, save for that of Constantinople and its immediate vicinity. Clearly, the partitioning of the field into "schools" introduced by Millet – regardless whether it may be deemed the 'cause', or the 'effect' of the described phenomena – became a turning point in the historiography of medieval architecture in the Balkans. After ca. 1920, exclusively national historiographies were on the rise in all Balkan states. As a direct consequence of these developments, consciousness of the broader Byzantine architectural tradition declined. As a result, many of the issues central for its understanding have remained unresolved. In the process, however, many of the developments within the so-called 'national schools' have also been deprived of clearer understanding. Satisfied with the searching for clues exclusively on the territory of individual national states, scholars engaging in such practices commonly were unable to answer critical questions or, alternatively, were misled in their conclusions by following wrong leads, usually the only ones available to them under the artificially self-imposed constraints.

It is within the study of Late Byzantine architecture – geographically situated almost exclusively on the territory of the Balkan Peninsula – that the shortcomings of modern scholarship are most readily apparent. Regional characteristics and distinctions that do exist between various developments notwithstanding, a proper understanding of broader developments within the framework of the Byzantine Empire and its relatively powerful new neighbors – Bulgaria and Serbia – is still substantially a 'terra incognita'. Paradoxically, the geographically most confined and chronologically shortest of all periods in the

---

21  G. Millet, *Recherches sur l'iconographie de l'Évangile* (Paris, 1916), pp. 625-690, where the "Macedonian School" is perceived as having been open to influences from "the Orient and Italy" in contrast to the more conservative "Cretan School".

22  P. Miljković-Pepek, "L'architecture chrétienne chez les Slaves macédoniens à partir d'avant la moitié du IXe jusqu'a la fin du XIIe siècle," *The 17th International Byzantine Congress, Major Papers* (Washington, D.C., 1986), pp. 483-500, and ten years later G. M. Velenis, "Macedonian School in Architecture of the Middle and Late Byzantine Period," *Byzantium: Identity, Image and Influence. XIX International Congress of Byzantine Studies*, vol. 1, ed. K. Fledelius (Copenhagen, 1996), pp. 500-505. A. Bryer, "The Rise and Fall of the Macedonian School of Byzantine Art (1910-1962)," *Ourselves and Others*, ed. P. Mackenridge (Oxford, 1997), pp. 79-87, prematurely declared that the concept had run its course as of 1962.

Byzantine Empire's long history – the Palaeologan era – in cultural terms still remains remarkably opaque in many respects. Despite inroads made in the last forty years, Late Byzantine architecture is still waiting for the long since anticipated synthesis. Various aspects of this rich international heritage have been studied, but the total picture is still elusive. The approaches attempted on a number of occasions by scholars such as Krautheimer and Mango and some of their followers have, it must be admitted, amounted to little more than failure.[23] The problem, it would seem, is predominantly of a methodological nature and lies in the fact that a synthesis of Late Byzantine architecture cannot be produced simply as a sum of smaller independent studies devoted to monuments on territories of different modern states. Looking at the developments in Greece, Serbia, Bulgaria, Albania, etc. independently from each other cannot yield a coherent picture of Late Byzantine architecture and, if attempted thus again in the future, it will inevitably lead down the same wrong paths that have been traversed before.

We must recognize that Late Byzantine architecture flourished on a territory larger than that of the Byzantine Empire in the fourteenth century, as well as larger than any of the modern states in the Balkans. Understanding its dynamic, therefore, mandates crossing medieval and, above all, modern national state boundaries and analyzing the material *collectively* without the imposition of artificial constraints that have been summarily imposed in the past. Only when this will have been accomplished, will the larger picture of Late Byzantine architecture begin to emerge, along with the more realistic understanding of all of the local variants which – of course – did exist.

---

23  S. Ćurčić, "Religious Setting of the Late Byzantine Sphere," *Byzantium: Faith and Power (1261-1557)*, ed. H. C. Evans (New York, 2004), pp. 65-77, esp. p. 65 and fn. 2, briefly highlights some of the writings of broader historiographical significance. One of them, H. Hallensleben, review of R. Krautheimer, Early Christian and Byzantine Architecture (1965), *Byzantinische Zeitschrift* 66 (1973), pp. 120-132, despite its excessive focus on minutiae, is the only substantial critique of earlier scholarship. Unfortunately, Hallensleben's intention to write a book on Late Byzantine architecture never materialized.

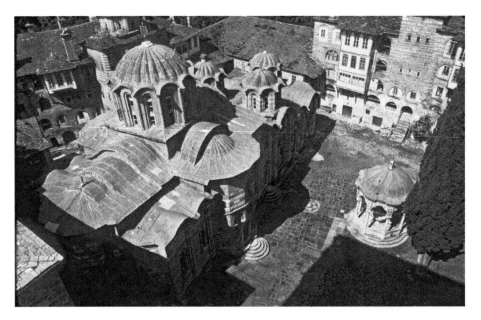

*Fig. 6: Hilandar Monastery, Katholikon, from NE (photo: author)*

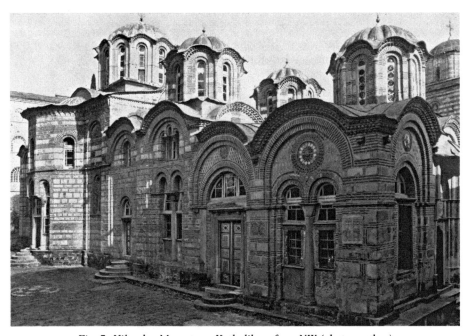

*Fig. 7: Hilandar Monastery, Katholikon, from NW (photo: author)*

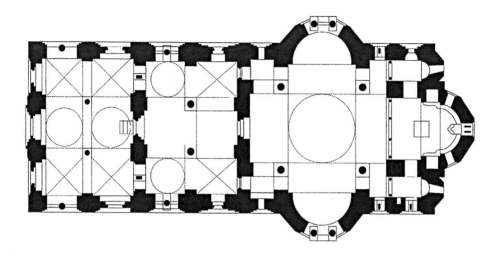

*Fig. 8: Hilandar Monastery, Katholikon, plan (delineated by J. Bogdanović)*

## V. The Case of the Katholikon of Hilandar Monastery

To understand the described difficulties resulting from the segmented approach to the study of Late Byzantine architecture as it has been practiced we may turn to a paradigmatic case par-excellence, the Katholikon of Hilandar Monastery on Mount Athos, arguably one of the most important monuments of this epoch (Figs. 6 and 7). Long since accepted as one of the masterpieces of Palaeologan architecture, its genesis is still a mystery, despite the fact that its patronage was never in doubt. Commissioned by the Serbian King Milutin (1282-1321), its construction probably began in 1303. As such, this would have been the first and one of the finest architectural commissions of the Serbian king, despite the fact that the beginning of its construction occurred over twenty years after his assumption to the throne. Though its master builder remains unknown, he and the building crew – most scholars agree – must have originated from within the Byzantine Empire (Fig. 8). It was Gabriel Millet, in fact, who was the first to suggest that the master builder of the Hilandar Katholikon must have come to Mt. Athos from Constantinople. Others have advocated alternative possibilities – Thessaloniki, Thessaloniki and Constantinople, Mt. Athos or Serbia and Con-

stantinople.[24] Uncertainties regarding the dating of the Hilandar Katholikon, including its exonarthex, given the highly fluid situation during the last decades of the thirteen and the first decades of the fourteenth century within the Byzantine state, have induced the said proliferation of different ideas in modern historiography, but with results that have not proven satisfactory.

Not wishing to suggest that the solution to this problem is readily within reach, I believe that the parameters within which the issue has been viewed have not been sufficiently broad. In a recently published study on the role of Thessaloniki in the development of church architecture of the Balkans, I argued that during the last two decades of the thirteenth century the architecture in Thessaloniki itself was shaped by the influx of builders and artisans from Epiros and from Nicaea following the re-establishment of the Byzantine Empire in 1261.[25] There can be no doubt that the political disintegration of the 'Despotate of Epiros' and the 'Empire of Nicea' must have caused a dispersal of builders from those territories looking for work elsewhere.[26] Likewise, there can be no doubt that by ca. 1280 both Thessaloniki and Constantinople once again became major centers of building activity. The renewed interest in building in these centers, where construction had practically ground to a halt during the preceding six to seven decades, must have created an unprecedented and sudden demand for builders. In the case of Thessaloniki the demand must have been even greater because of the increased need for fortification construction in the area of Macedonia on account of Serbia's expansionist policies directed against Byzantium that lasted from 1282 to 1299 (Fig. 9).[27] Having lost the continuity of earlier steady production on account of the thirteenth-century political developments, but experiencing a major new demand for building in the decades around 1300, both Thessaloniki and Constantinople experienced an influx of builders from outside. Their architecture, as a result of these circumstances, reveals an uncharacteristic inconsistency in matters related to the style of buildings. Scholarship has not addressed this issue adequately. It is necessary to recognize not only that

---

24  M. Čanak-Medić, "Sto godina proučavanja arhitekture manastira Hilandara. Stanje proučenosti i pokrenuta pitanja" (Engl. sum.: "A Centenary of the Study of the Architecture of Hilandar Monastery"), *Osam vekova Hilandara. Istorija, duhovni život, književnost, umetnost i arhitektura*, ed. V. Korać (Belgrade, 2000), pp. 447-56, where the extensive historiography pertaining to the Katholikon of Hilandar Monastery is analyzed.

25  S. Ćurčić, "The Role of Late Byzantine Thessaloniki in Church Architecture in the Balkans," *Dumbarton Oaks Papers* 57 (2003), pp. 65-84.

26  Ibid., esp. pp. 83-84.

27  M. Popović, "Les forteresses dans les régions des conflits byzantinoserbes au XIVe siècle," *Vizantio kai Servia kata ton ID aiôna*, eds. E. Papadopoulou and D. Dialeti (Athens, 1996), pp. 67-87.

differences between architecture of Constantinople and Thessaloniki did exist, but also that there were significant differences amongst the architecture of individual buildings within both centers. In analyzing the architecture of the Hilandar Katholikon, therefore, we cannot simply think of either Constantinople or Thessaloniki as having been an immediate source of its builders. The situation, most certainly, was more complex. Although I am inclined to think that Millet may have been right in stressing the link with Constantinople, I am also conscious of the fact that several of the building characteristics which he singled out as demonstrating the alleged links with the Byzantine capital are not to be found in the architecture of Constantinople from around 1300, but actually in its building heritage a century or more older. It would appear that even Millet himself may have been aware of these discrepancies, though he did not articulate the problem sufficiently. Curiously, although he correctly attributed the Katholikon of Hilandar to King Milutin, he ascribed a mistaken date of *1200* (!) as the time of its construction.[28] Millet and others who relied on his book have all ignored both the dating mistake, as well as the implicit issue of the building style. How, then, should such a serious problem be explained? Firm proofs of what may have occurred were probably preserved in buildings beyond Constantinople that no longer survive. A hypothetical explanation, in my opinion, is nevertheless possible. Of particular relevance for the understanding of this development would have been thirteenth-century architecture of Nicaea and the territories under its control. Nicaea became the seat of imperial administration following the fall of Constantinople to the Crusaders in 1204. The foundations of several of its thirteen century Byzantine churches, destroyed in Ottoman times, have been uncovered. Unmistakably, they share planning characteristics, floor patterns and various details with Middle Byzantine churches of Constantinople. Outstanding among these is the so-called "Church A", with its characteristic cross-in-square plan displaying a rigorous relationship between pilaster strips articulating its lateral facades and the placement of interior responds related to the vaulting system and, especially, the four central columns supporting the main dome (Fig. 10).[29] The plan of the Hilandar Katholikon, notwithstanding its projecting lateral apses, displays similarities with "Church A" in Nicaea with which it shares the characteristic use of pilasters on its façades and matching responds on the interior, all related to the system of vaulting and the position of the four columns supporting the main dome (Fig. 8). While comparable church plans can neither be found in fourteenth-century Constantinople nor in Thessaloniki, it is noteworthy

---

28  Millet, *L'ancien art serbe*, p. 95.
29  U. Peschlow, "The Churches of Nicaea-Iznik," *Iznik throughout History*, eds. I. Akbaygil et al. (Istanbul, 2004), pp. 201-218, esp. pp. 208-210.

that they do appear as far afield as the Church of Aphendiko at Vrontochion Monastery in Mistra and the Church of the Mother of God at Matejić Monastery, northeast of Skopje (Figs. 11 and 12).[30] The former church, dating from 1310-22, and the latter, from ca. 1343-52, both display unique planning characteristics relatable to Middle Byzantine Constantinople. As in the case of the Hilandar Katholikon, it is possible that the plans of these churches may also be traceable to thirteenth-century architecture of Nicaea, the probable 'missing link' in the chain going back to Middle Byzantine Constantinople.

Arguing for the precise origins of the Hilandar Katholikon would require far more space than can be allotted to it here. The main point, however, has been made. The idiosyncrasies of the architecture of the Hilandar Katholikon are too complex for a systematic analysis unless the research net is cast widely enough. Characteristically, this has not been done thus far. Bringing into consideration the potential role of Nicaea opens a new possibility for our understanding of how ideas may have been transmitted and why some of them could have survived over longer periods of time, despite historical discontinuities that dominate our field of vision. In recognizing the potentially significant role of Nicaea, the Byzantine capital in exile, we also recognize how easily our general understanding of certain phenomena could be distorted.

---

30  Regarding the problem of façade articulation in relationship to the internal spatial disposition of Byzantine church architecture, see S. Ćurčić, "Articulation of Church Façades during the First Half of the Fourteenth Century," *Vizantijska umetnost početkom 14. veka* (L'art byzantin au debut du XIVe siècle), ed. S. Petković (Belgrade, 1978), pp. 17-27; regarding the role of the architecture of Constantinople in the development of architecture in Serbia around 1350, see S. Ćurčić, "Architecture in the Byzantine Sphere of Influence around the Middle of the Fourteenth Century," *Dečani i vizantijska umetnost sredinom XIV veka* (Dečani et l'art byzantin au milieu du XIVe siècle), ed. V. J. Djurić (Belgrade, 1989), pp. 55-68. For Aphendiko at Mistra, see H. Hallensleben, "Untersuchungen zur Genesis und Typologie des Mystratypus," *Marburger Jahbuch für Kunstwissenschaft* 18 (1969), pp. 105-118, whose gallery level features Constantinopolitan cross-in-square scheme (Fig. 3) juxtaposed over a basilican schema (Fig. 2); for Matejic, see: Ćurčić, *Architecture in the Balkans* (see fn. 1), pp. 641-643.

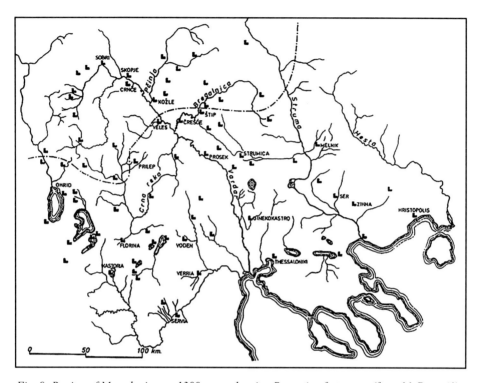

*Fig. 9: Region of Macedonia, ca. 1300; map showing Byzantine fortresses (from M. Popović)*

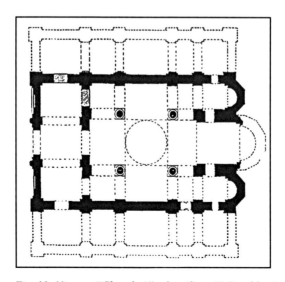

*Fig. 10: Nicaea, "Church A", plan (from U. Peschlow)*

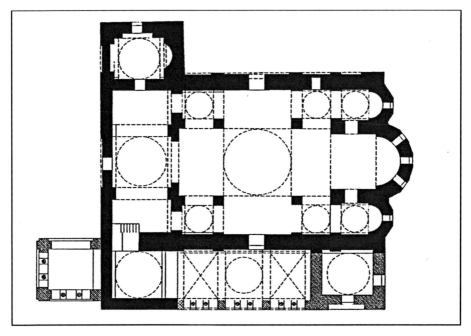

*Fig. 11: Mistra, Aphendiko Church, plan (delineated by J. Bogdanović)*

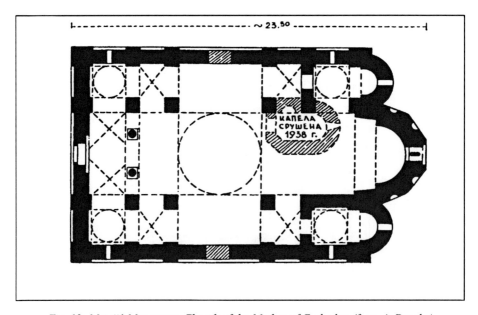

*Fig. 12: Matejić Monastery, Church of the Mother of God, plan (from A. Deroko)*

## VI.   The Case of Skopje

In the same vein, something must be said about another major center, whose role in the development of architecture in the later Middle Ages must have been major. The center in question is the city of Skopje.[31] Built on the upper course of the Vardar river, Skopje was probably the medieval descendent of ancient Scupi, a prosperous late-antique city devastated by the earthquake of 518. The new city, built in the vicinity on a new site, became important only during the Middle Byzantine period. Following a period of Bulgarian control, it was re-claimed by the Byzantines in 1018 under Basil II. Written records mention two churches dedicated to St. George, both possibly being attributable to Byzantine Emperor Romanos III Argyros (1028-34), and the cathedral church of the Mother of God probably also having been built by the Byzantines. Mentioned in 1204, it was later restored by King Milutin after Skopje passed into his hands in 1282.[32]

King Milutin was engaged in active re-construction and expansion of the Byzantine city. Written sources credit him with the construction of as many as sixteen new churches, a number probably exaggerated, but nonetheless indicative of the lively building activity in the city around 1300. The most important among his commissions was the church of the Mother of God "Trojeručica" (Panagia Tricheiroussa, the Three-Handed Virgin), the center of whose cult was at Hilandar Monastery on Mount Athos. Hence, there are good reasons to postulate a link between these two major churches both built under the patronage of King Milutin. As relevant as this observation may be, it can only remain a hypothesis, for the church of the Mother of God Trojeručica has disappeared without a trace; not even its location within the city is known. Unfortunately, this is also true of all of the medieval architecture of Skopje.[33] Following its takeover

---

31   A history of the medieval city of Skopje is yet to be written; for a brief outline, see A. Deroko, "Srednjovekovni grad Skoplje" (French sum.: "Le château fort medieval Soplje"), *Spomenik. Srpska akademija nauka i umetnosti*, CXX (Belgrade, 1971), pp. 3-16; see also I. Mikulčić, *Staro Skopje so okolnite tvrdini* (Skopje und umgebende Festungen in der Antike und im Mittelalter) (Skopje, 1982), pp. 118-127; the paucity of documentary evidence regarding the city is reflected in Lj. Maksimović, *Grad u Vizantiji. Ogledi o društvu poznovizantijskog doba* (Town in Byzantium. Studies on Byzantine Society during the Late Byzantine Era) (Belgrade, 2003), who does not refer to Skopje at all.

32   V. Petkovic, *Pregled crkvenih spomenika kroz povesnicu srpskog naroda* (Revue des monuments réligieux dans l'histoire du peuple serbe) (Belgrade, 1950), pp. 298-99.

33   A recent discovery of the remains of an unidentified medieval church in the medieval fortress (Kale) of Skopje is of considerable significance, but the results have not yet been published. This important discovery has been brought to my attention by Dr. Vujadin Ivanišević, to whom I am grateful.

by the Ottomans in 1391, the face of medieval Skopje was completely altered. Within several decades, a new, Ottoman city rose over its substantially destroyed medieval predecessor.[34] Of major strategic importance, the new city, by the end of the fifteenth century, must have competed with Thessaloniki in every respect. For the history of Byzantine and Serbian architecture in the Balkans, Skopje remains *the* major lacuna, without which regional developments in architecture of the 11th-14th centuries cannot be fully understood. It is the fourteenth-century architecture of several royal and mostly private monastic foundations on the outskirts of Skopje that offer some clues regarding what the architecture of this important center may have been like.[35] Clearly, despite the relatively good preservation of several of these monuments, the reconstruction of the entire picture will forever remain incomplete. Despite such discouraging prospects, all efforts must be made to bring as much evidence to bear on the study of the central problem – how the architecture associated with Constantinople made such a broad impact on the developments in the Balkans during the last decades of the thirteenth and the first decades of the fourteenth century. Such a pursuit, above all, implies expanding territorial parameters of research beyond those determined by the current national boundaries within the region. Without such efforts, not only will no progress be possible in illuminating the mechanisms of the relationship between Serbia and Byzantium in the realm of architecture during the first half of the fourteenth century, but the equally important question of the genesis of Serbia's so-called "Morava School" architecture during the second half of the same century will continue to elude us.

## Conclusion

The foregoing analysis of the century-long developments of the historiography of Byzantine and Serbian architecture in their Balkan context has demonstrated their checkered achievements. Within their narrowly defined national frames, some of the contributions have nonetheless been noteworthy and important. The principal larger failure, however, has been the absence of a wider frame of reference encompassing developments within the geographic space of the Balkan as a whole. As a result of the unfortunate divisions into national and sub-national

---

34  L. Kumbardži-Bogoevik, *Osmanliski spomenici vo Skopje* (Ottoman Monuments in Skopje) (Skopje, 1998).

35  Ćurčić, "The Role" (see fn. 25), pp. 80-83; see also: J. Bogdanović, "Regional Developments in Late Byzantine Achitecture and the Question of 'Building Schools'. An Overlooked Case of the Fourteenth-Century Churches from the Region of Skopje," *Byzantinoslavica* LXIX, 1-2 (2011), pp. 219-266.

"schools" of architecture introduced some nine decades ago, scholarship in all Balkan countries has suffered from serious parochialization. Worse than simply pandering to narrow nationalist sentiments within the different newly formed states, various historical constructs that have been produced over time have been patently wrong in their conclusions. To put it in a nutshell, and limiting the observations to the primary context of this paper, it is clear that the architecture of medieval Serbia cannot be understood without taking the role of the Byzantine architectural tradition into account. It is equally clear, on the other hand, that our understanding of late Byzantine architecture between ca. 1300 and 1450 cannot be complete without considering the role of Serbia.

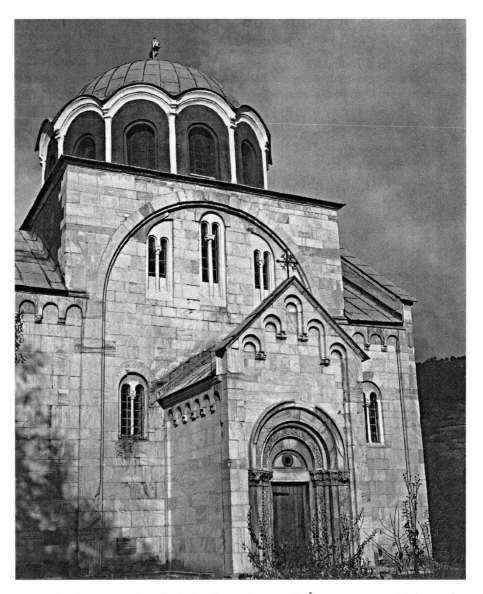

*Church of the Virgin Mary, Studenica, from: V. Korać, M. Šuput, Byzanz. Architektur und Ornamentik (Düsseldorf und Zürich, 2000)*

# Studenica. A New Perspective?

*Jelena Erdeljan*

The church of the Virgin at Studenica functioned as a sign, a paradigm throughout the Serbian Middle Ages and beyond.[1] Still, even with all the historiography devoted to the various aspects of the architecture, painting and treasures of this foundation of Stefan Nemanja,[2] a careful (re)reading of the written sources, as much as of its visual identity, may open a new perspective on the historical circumstances surrounding its founding and thus also on its original purpose as well as on the interaction of such roots with the contents and meanings which were subsequently introduced to it and which ultimately defined it as the core of identity of the Nemanide state and church.

As we learn from the long and abundant historiography on this monastery, the cornerstone of perceiving the identity and significance of Studenica, both in its own day and throughout the centuries which ensued, is the fact that, following Nemanja's death in Chilandar on Mt. Athos in 1199, it was to this monastery that Sava transferred the body of his father in 1207, whereupon it became the center of his cult and, thus, the pivotal point of development of Nemanide royal ideology.[3] However, it seems curious, to say the least, that the

---

1   V. J. Djurić, "Tabernacle du peuple serbe," *Blago manastira Studenice*, V. J. Djurić, ed. (Belgrade, 1988), pp. 20-25.

2   For seminal monographs and studies on Studenica see G. Babić, V. Korać, S. Ćirković, *Studenica* (Belgrade, 1986); M. Kašanin, M. Čanak-Medić, J. Maksimović, B. Todić, M. Šakota, *Manastir Studenica* (Belgrade, 1986); M. Čanak-Medić, Đ. Bošković, *L'architecture de l'époque de Nemanja, I, Les églises de Toplica et des vallées de l'Ibar et de Morava* (Belgrade, 1986); *Studenica i vizantijska umetnost oko 1200. godine, Međunarodni naučni skup povodom 800 godina manastira Studenica i stogodišnjice SA-NU* (Studenica et l'art byzantin autour de l'année 1200. A l'occasion de la célébration de 800 ans du monastère de Studenica et de centième anniversaire de l'Académie serbe des sciences et des arts), ed. V. Korać (Belgrade, 1988); *Osam vekova Studenice. Zbornik radova, episkop žički Stefan*, Lj. Durković-Jakšić, eds. A. Jevtić, D. Lj. Kašić, S. Mandić, Đ. Trifunović (Belgrade, 1986); *Blago manastira Studenice*, ed. V. J. Djurić (Belgrade, 1988).

3   On the structure and development of the cult and the ideological premises and implications of Nemanja's grave in Studenica see the seminal studies by D. Popović, *Srpski vladarski grob u srednjem veku* (Serbian Royal Tomb in the Middle Ages) (Belgrade, 1992), pp. 24-47; ead., "Svetiteljsko proslavljanje Simeona Nemanje. Prilog proučavanju kulta moštiju kod Srba" (Eng. sum.: "The Cult of St. Simeon Nemanja: A Contribution to the Study of the Cult of Relics among the Serbs"), *Pod okriljem svetosti. Kult svetih vladara i relikvija u srednjovekovnoj Srbiji* (Under the Auspices of Sanctity. The Cult of Holy

existing written sources, the Serbian medieval biographies of Nemanja composed by Sava Nemanjić, Stefan Prvovenčani and Domentijan, make no mention at all of Studenica actually being *founded* as a mausoleum.[4] Particularly telling in that respect is the text of the vita of St. Symeon written in 1208 by Nemanja's son, Sava. Having been composed as the introductory part to the typikon of Studenica, this text focuses primarily on aspects of Nemanja's life as *ktetor* and monk and it is, therefore, highly indicative that precisely this composition should miss out the funerary purpose (presumably) intended for the church of the Virgin and the monastery of Studenica by its founder.[5]

On the other hand, in investigations regarding the question of Nemanja's final resting place it appears that the church of St. Nicholas at Kuršumlija in Toplica, one of his first foundations with highly significant political implications of deep impact on his personal and, thus, also the history of his state,[6] has

---

Rulers and Relics in Medieval Serbia) (Belgrade, 2006), pp. 27-40; ead., "O nastanku kulta svetog Simeona" (Eng. sum.: "On the Establishment of the Cult of Saint Simeon"), ibid., pp. 41-73. Following much scholarly debate, it has been determined that the translatio of Nemanja's body from Chilandar to Studenica took place in 1207; Lj. Maksimović, "O godini prenosa Nemanjinih moštiju u Srbiju" (Fr. sum: "Sur l'année du transfer en Serbie des reliques de Stefan Nemanja"), *Zbornik Radova Vizantološkog Instituta XXIV-XXV* (Recueil des travaux de l'Institut d'études byzantines XXIV-XXV) further in the text *ZRVI* (1986), pp. 437-444.

4    Although this has, naturally, been noted by researchers of Studenica and Nemanja's grave in particular (D. Popović, *Srpski vladarski*, p. 25), historio-graphy has it that Nemanja made the decision to be buried in Studenica if not immediately upon its founding then at some point during the long years of its construction and certainly during his lifetime (loc. cit.). This account is grounded on later, XIII century hagiographies of St. Symeon by Domentijan and Teodosije in whose vita texts we find that it was Nemanja on his deathbed in Chilandar who ordered his son Sava to transfer his body to Studenica; Domenitjan, *Život Svetoga Save i život Svetoga Simeona*, prevod L. Mirković, priredila R. Marinković (Belgrade, 1988), p. 287; Teodosije, *Žitije svetog Save*, preveo L. Mirković, prevod redigovao D. Bodanović (Belgrade, 1984), p. 57.

5    Sv. Sava, *Život svetoga Simeona Nemanje, Spisi svetoga save i Stevana Prvovenčanog*, preveo L. Mirković (Belgrade, 1939), pp. 109-135, on the founding of Studenica esp. pp. 109-111. Cf. also other Serbian medieval hagiographies of Symeon Nemanja: Stevan Prvovenčani, *Život i dela (podvizi) svetoga i blaženoga i prepodobnoga oca našega Simeona*, ibid., pp. 169-222, on the founding of Studenica esp. pp. 184-187; Domentijan, op. cit., on the founding of Studenica p. 255.

6    I. Stevović, "Historical and Artistic Time in the Architecture of Medieval Serbia: 12th Century," *Arhitektura Vizantii i drevnei Rusi IX-XII vekov. Materialy meždunarodnogo seminara 17-21 nojabrja 2009 goda* (Architecture of Byzantium and Kievan Rus from the 9th to the 12th Century. Materials of the International Seminar November 17-21, 2009), ed. D. D. Elšin (St. Petersburg, 2010), pp. 148-163; id., "Istorijski izvor i istorijskoumetničko tumačenje: Bogorodičina crkva u Toplici" (Eng. sum.: Written

systemmatically been left out of the picture. Could this church originally have been erected for that purpose? In the course of archeological investigation, a meticulously constructed underground funerary vault has been uncovered in the south parecclesion, raised contemporaneously with the church, which remained empty throughout the centuries.[7]

Instead of taking for granted that Studenica was conceived, from the start, as the final resting place of Nemanja, which, as we have pointed out, can not find corroboration in the written sources, we should consider the possibility that in the course of historical events around the year 1200, and given the developments on the Serbian political scene – the rise to power of Stefan Prvovenčani, his clash with his brother Vukan, Sava's role as mediator in their feud, his own consecration as archimandritos in Thessaloniki in 1204 as the initial and crucial step in breaking away from the Archbishopric of Ohrid and the formation of an autocephalous Serbian church[8] – as well as those dictated by the major powers in South Eastern Europe and the Mediterranean around the turn of the century, Byzantium, Hungary, the Crusaders, the Venetians,[9] Sava made a decision of far-reaching impact on the political and ecclesiastical history of Serbia, once Nemanja had already been on Mt. Athos, possibly even as late as immediately upon his death (1199/1200), or indeed after 1204, to transfer the body of his father to Serbia, and more specifically to Studenica, and to *thus* define this place as the nucleus of the Nemanide dynastic cult and the seed out of which grew both the kingship of the Nemanides and the autonomy of the Serbian church. Seen from this perspective, to underline the true meaning and implications of this act, as well as the farsightedness of the founder of the dynasty in determining the centrality of Studenica as an axis of dynastic legitimacy, this could be why the ideologically intoned hagiographies of St. Symeon written by Domentijan and Teodosije in the XIII and XIV centuries, at the height of

---

Historical Sources and Art-Historical Interpretation: The Case of the Church of the Virgin at Toplica"), *Zograf* 35 (2011), pp. 73-92.

7 M. Čanak-Medić, Đ. Bošković, op. cit., pp. 17, 20.

8 S. Ćirković, "Unutrašnje i spoljne krize u vreme Nemanjinih naslednika," *Istorija srpskog naroda* I, ed. S. Ćirković (Belgrade, 1981), pp. 263-272; B. Ferjančić, "Odbrana Nemanjinog nasleđa – Srbija postaje kraljevina," ibid., pp. 297-314; D. Bogdanović, "Preobražaj srpske crkve," ibid., pp. 315-327; M. M. Petrović, *Studenički tipik i samostalnost srpske crkve* (Gornji Milanoviac, 1986). In the Vita of St. Symeon, Sava says that his brothers, Stefan and Vukan, asked him in a letter to transfer the body of their father to Serbia because of the unstable situation on Mt. Athos and also in order "da se blagoslov njegov javi ispunjen na nama" ("we may witness the fulfilment of his blessing upon us," Eng. translation J. E.); Sv. Sava, op. cit., p. 132.

9 P. Stephenson, *Byzantium's Balkan Frontier. A Political Study of the Northern Balkans, 900-1204* (Cambridge, 2004).

Nemanide power, stress that it was already Nemanja who, on his deathbed, ordered Sava to transfer his bodily remains to the fatherland and lay them in Studenica.[10]

However, given the presumption that the funerary and dynastic function of the Virgin's church at Studenica was, in a manner of speaking, secondary, solely in a chronological sense, of course, the question arises: what kind of already existing political, ecclesiastic, visual entity Nemanja's body was transferred to. As far as we know, the construction of Studenica began around 1186. The church, as we learn from written sources, was only partly finished at the moment of Nemanja's abdication and departure for Mt. Athos in 1196. Its fresco decoration was completed in 1208/1209.[11] Why indeed did it take a full twenty-two years to complete the works on the church of the Virgin?

The 1207 *translatio* of the body of Nemanja from Chilandar to Studenica was certainly the final touch to creating a *par excellence* sacral focus of the Nemanide dynasty and the Serbian people. One crucial preceding event from that process that we know of from sources is the advent of a particle of the Holy Wood, incorporated into a personal pectoral, sent from Mt. Athos to Studenica by Nemanja in 1198 and, in the words of Stefan Prvovenčani, reposited in a "place already prepared for it" in the church of the Virgin.[12] Studenica thus effectively became a reliquary and a place of cult of the Holy Cross to which the body of Nemanja was introduced as the warrant of dynastic salvation and the cornerstone of its royal legitimacy which, in turn, was placed under the protection of the Holy Wood. That act was the initial and key element of a program which revolved around the True Cross. This is explicitly communicated by the dominant image of the Crucifixion covering practically the entire surface of the western wall of the naos and positioned in direct proximity to Nemanja's funerary structure in the church of the Virgin. The program of Studenica, doubtlessly fashioned by Sava, is thus similar in structure and a true precursor to that which he accomplished nearly three decades later and realized to its full potential in the church of the Savior at Žiča, the seat of the archbishopric and the

---

10  Domentijan, op. cit., 287; Teodosije, op. cit., p. 57.

11  On the chronology of construction of the church of the Virgin see M. Čanak-Medić, Đ. Bošković, op. cit., pp. 79-80.

12  S. Marjanović-Dušanić, "Vladarski znaci Stefana Nemanje" (Eng. sum.: "The ruler's insignia of Stefan Nemanja"), *Medjunarodni naučni skup Stefan Nemanja – Sveti Simeon Mirotočivi, Istorija i predanje* (Colloque scientifique international Stefan Nemanja – Saint Simeon Myroblite), ed. Jovanka Kalić (Belgrade, 2000), pp. 77-87, on the translation of the relic and the pectoral to Serbia esp. p. 81, with sources.

crowning church of Serbian kings, an axis of true faith and a New Jerusalem.[13] The moment of transfer of the Holy Cross to Serbia (1198) could well have been the turning point in its history and, what's more, in establishing the ultimate (visual) identity, chosen by Sava, for Studenica. The Studenica we know as of 1208/1209 could have been finalized during that ten year period, with the completion of painting and ultimate expression of identity in the fresco program which could, theoretically, have been produced even in the relatively short period between the transfer of Nemanja's relics in 1207 and the year 1208/1209 mentioned in the fresco inscription written out on the base of the dome.[14]

But what do we know of the concept, purpose, sacral contents and program of Studenica prior to 1198? And how, if indeed there was a different purpose, did it interact with the ultimate function of the Virgin's church as dynastic mausoleum and a Serbian New Jerusalem? What went on in the twelve years between the founding, associated with the year 1186, and the arrival of, first, Nemanja's pectoral with the relics of the True Cross (1198) and, ultimately, his own bodily remains (1207)? The key point, conceptually and materially, around which this issue revolves is Nemanja's grave. At the root of this problem lies actually the status of insufficient archeological investigation of the actual spot within the church which was Nemanja's second and final resting place at Studenica, located in the southwestern bay of the naos. It is regarded as an archetypal example of a Serbian royal funerary ensemble, consisting of a composite marble monument, i.e. sarcophagus and surrounding structures associated with the myroblitic performance of his relics.[15]

However, because this part of the Virgin's church has not yet been archeologically investigated, the question still remains whether there is any underground burial vault at all beneath the marble monument.[16] And, if such a structure does exist, what is its date and how does it relate chronologically to the foundations and subsequent phases of construction of the church. To make

---

13 On the program surrounding Nemanja's grave see D. Popović, *Srpski vladarski grob*, pp. 35-41; ead., "Svetiteljsko proslavljanje Simeona Nemanje;" ead., "Sacrae reliquiae Spasove crkve u Žiči" (Eng. sum.: "The *Sacrae reliquiae* of the Church of the Saviour at Žiča"), *Pod okriljem svetosti*, pp. 207-232.

14 For the fresco inscription mentioning the year 1208/1209 see M. Čanak-Medić, Đ. Bošković, op. cit., p. 80.

15 D. Popović, *Srpski vladarski grob*, pp. 30-31.

16 Eadem, pp. 29-30, points out that this problem is still open, but concludes that, given the confirmed and investigated existence of underground burial vaults in subsequent examples of Nemanide royal tombs from Gradac, Sopoćani and the Holy Archangels by Prizren, which were fashioned after the model of Studenica, such a subterranean chamber must also have been constructed in Studenica.

things more difficult, scholars note the absence of explicit mention in written
sources of the construction of Studenica as a funerary church, but still claim that
its initial cornerstone of identity and purpose of erection was the burial of
Nemanja and, furthermore, that this decision was made during his lifetime.[17]
Should there be an absence of such an underground structure, or should it
happen that its construction is not contemporaneous with the church, this would
open up the question of the sustainability of such premises. It may, in fact,
suggest that the concept of Studenica as the ultimate resting place of Stefan
Nemanja was a *secondary identity* of Studenica, one produced by Sava in
circumstances either immediately prior to Nemanja's passing away or following
that event and on the eve of the translation of his relics from Mt. Athos to
Serbia.

What is certainly a fact beyond any doubt concerning the chronology of
Studenica is that its very origins are associated with the watershed years of the
height of Nemanja's royal power on the one hand, and his taking the monastic
vow on the other. In order, however, to gain as clear a picture of the reasons and
purpose behind its founding as possible, we must widen the scope of inspection
to observe the broader framework of which Nemanja was an integral part,
namely the political and ecclesiastic fabric of the Byzantine Empire and the
Archbishopric of Ohrid in the second half of the XII century.[18] It is, we believe,
his position within this broader structure, which was instrumentally correlated
with the original puropose and visual identity of Studenica that communicated
perfectly with the purpose it received after 1207 or, rather, as of 1208/1209.
Therefore the transformation, or – even more precisely – the appropriation or
(re)contextualization of the original idea of Studenica within the process of
turning it into Sava's first New Jerusalem in the fatherland and a center of
dynastic cult was a smooth, seamless endeavor, a natural consequence.

In our opinion, the origins of Studenica are most closely associated with the
question of relations between Nemanja and the Bishopric of Ras.[19] Ultimately,

---

17  Eadem, p. 25.
18  J. Kalić, "Crkvene prilike u srpskim zemljama do stvaranja arhiepiskopije 1219. godine"
(Fr. sum.: "L'organisation de l'Église dans les pays serbes avant la fondation de
l'archevêché serbe en 1219"), *Medjunarodni naučni skup Sava Nemanjić – Sveti Sava.
Istorija i predanje* (Colloque scientifique Sava Nemanjić – Saint Sava. Histoire et tradi-
tion), ed. V. Đurić (Belgrade, 1979), pp. 27-53; ead., "Srpska država i Ohridska arhiepis-
kopija u XII veku" (Fr. sum.: "L'État serbe et l'archevêché d'Ochrid au XIIe siècle"),
*ZRVI* 44/1 (2007), pp. 197-208.
19  J. Kalić, "L'époque de Studenica dans l'histoire serbe," *Studenica i vizantijska umetnost
oko 1200. godine*, pp. 25-34, esp. pp. 30-32. In this text J. Kalić writes about Nemanja's
activities after the year 1180 as well as those related to the building of Studenica and

this is a question of relations of (a) Serbian clan ruler(s) with the Archbishopric of Ohrid as the highest instance of Byzantine ecclesiastic jurisdiction in the central Balkans, established following the destruction of the so-called Macedonian empire of Samuilo in 1018 by emperor Basil II. At that time, the bishopric see at Ras became one of the most significant bishopric sees within the newly established Archbishopric of Ohrid, the jurisdiction of which spread over all the lands that had once been under the rule of Samuilo and his heirs. In this way, Byzantium (re)gained an instrument of high leverage of power deep inside the Balkan hinterland, in an area that was soon to become the new center of the Serbian state which was ecclesiastically dependent, subjugated to the bishops of Ras who lived along the Serbian jupans and were in constant contact with them. It was that particular aspect of Byzantine presence and influence that additionally forged strong ties between the jupans of Ras and Constantinople, reminding them of their common confession along with the acknowledgment of highest power of the Byzantine emperor, which was an inextricable part of inclusion in the same confession and of belonging to the Byzantine church organization.

In founding the Archbishopric of Ohrid, actually by reorganizing Samuilo's patriarchate, emperor Basil II already clearly defined that the role it was to play in subjugating and, in a way, controlling the Slavic and Serbian tribes was embodied in the specific connection between the archbishop of Ohrid and the emperor of Byzantium. The investiture of the Archbishop of Ohrid was, namely, performed by the Byzantine emperor himself and was thus not subjected to the jurisdiction of the patriarch of Constantinople in the usual manner of prelates of other archbishoprics, nor was he a part of the hierarchy of the Constantinopolitan church. Along with their shepardly duties among the flock entrusted to their spiritual care and guidance, archbishops of Ohrid always played a prominent political role in the milieu of their activity as direct representatives of the Basileus among the Slavic tribes.[20] Therefore, a benevolent relationship, a

states that they were opposed to the interests of the bishop of Ras and the Archbishopric of Ohrid. But he also notes that there is no evidence in the sources which would testify clearly to the status and nature of Nemanja's relations with those institutions. She points out that Studenica was raised on purpose at a distance from the center of the Bishopric of Ras, as some sort of counter axis. However, in view of the text and XII century written sources published recently by the same author (J. Kalić, "Srpska država i Ohridska arhiepiskopija u XII veku," passim) these issues, which we shall discuss further on in the text, can now be obseved from an entirely different angle and against a much broader horizon.

20 V. Stanković, *Manojlo Komnin. Vizantijski car (1143-1180)* (Belgrade, 2008), pp. 264-265.

favorable stance on the part of the bishop of Ras, i.e. a representative and member of the ecclesiastical hierarchy of the Archbishopric of Ohrid, was highly instrumental in promoting the fortune and political impact of any local ruler or strongman and exerted decisive influence in resolving local internal power struggles, among others, also within the clans of Serbian ruling families. As important as it was for the Serbs, this specific relationship was equally significant for the Byzantines, for it was an instrument of inclusion of the Slavic Balkan population in the institutions, framework and far-reaching policies and political goals of the Empire.

This aspect of the story gained particular prominence during the XII century with the need to reassert the presence and the power of the Empire in the central Balkans following the rise of the Normans, Venice and Hungary on the Dalmatian coast and along the Danube frontier and their gradual encroachment on Byzantine spheres of influence as well as their offering of alternative sources of patronage for local rulers, which resulted in a loss of dominance over territories and cities (and inclusion of one-time allies such as the Diocletian clans of Serbian jupans) previously controlled by Byzantium.[21] Under such circumstances, the Bishopric of Ras was equally significant for the Byzantines as a means of drawing the Serbian rulers and population into their fold, including them in the ecclesiastical and confessional sphere of the Orthodox church and drawing them away from the growing influence of the Catholic bishoprics in Duklja and Zeta, as it was for certain branches of the Serbian ruling family (as exemplified by the clash between Desa and Uroš) who found their new stronghold under the protection of the emperor and bishops of Ras in an area removed from the original nucleus of their patrimonial lands, an area that was soon to become the center of the young Nemanide state.[22]

In the case of Nemanja, the basic governing principles underlying the above described interconnected and interest-based relations between Serbian rulers, Byzantine emperors and high-ranking representatives of the Archbishopric of Ohrid are attested by contemporary XII century sources and, what's more, appear to have been the crucial element in constructing his royal status and identity and thus, logically, also his ktetorship. Moreover, the key person in this matter was none other than the archbishop of Ohrid himself, John (Adrian) Komnenos (in office from 1140 to 1164) – a member of the innermost circle of the imperial household, nephew of emperor Alexios I and son of his influential brother, protosebastos Isaac Komnenos, thus first cousin of emperor John II and

---

21  P. Stephenson, op. cit., esp. Chapter 8: Advancing the Frontier, pp. 239-274.
22  V. Stanković, op. cit., pp. 264-265.; J. Kalić, "Srpska država i Ohridska arhiepiskopija u XII veku," passim.

uncle of emperor Manuel I.[23] A close study of XII century sources, namely the Russian Lavrentijevski chronograph, offers proof that Archbishop John was a part of the imperial entourage accompanying Manuel I on his way to negotiations with the Hungarians held in Belgrade in 1163 regarding the marriage arrangement between the emperor's daughter Maria and Bela, brother of king Stephen III. According to Kinnamos, and confirmed by Serbian sources, the emperor and his suite, on their way to Belgrade, stopped at Niš[24], where he met with Stefan Nemanja, of whose "extraordinary prudence and humility" he had already heard, and bestowed upon him some sort of imperial office and a part of the imperial lands in the region of Dubočica.[25] Crucial evidence of his virtue was obviously supplied by the Archbishop of Ohrid, John Adrian Komnenos, who was, moreover, personally present at the meeting in Niš as part of the royal embassy, and who must have been already well aware of Nemanja's activities and qualities, as he was the officiating archiereos of the archdiocese within which Nemanja received his second baptism in the cathedral church of SS. Peter and Paul at Ras from the hand of Bishop Leontios.[26] This baptism could indeed be interpreted as more than just an act of personal devotion but ra-ther as a sign of fealty to the Byzantine church and the influential Archbishopric of Ohrid, which resulted in the endorsement of Nemanja's position as opposed to that of his brothers and, ultimately, his domination over Serbian lands as grand jupanus. With such support, under the auspices of the bishop of Niš, an exponent of ecclesiastical hierarchy of the Archbishopric of Ohrid, Nemanja accomplished his ktetorial building activities in Toplica which, as we know from Serbian sources, resulted in animosities and open war between him and his brothers, obviously because theses foundations served as demonstration of his chosen, elevated status in the eyes of the Byzantine ecclesiastic and, ultimately, imperial establishment. The erection of the monastery of St. George at Ras (Đurđevi Stupovi) was, finally, not only a symbol of Nemanja's triumph and a votive offering to the holy patron with whose aid he was freed from imprison-

---

23 Eadem, p. 201. For the source see G. Prinzing, "Wer war der "bulgarische Bischof Adri-an" der Laurentinus-Chronik sub anno 1164?," *Jahrbücher für Geschichte Osteuropas* 36 (1988), pp. 552-557.

24 J. Kalić, "Srpska država i Ohridska arhiepiskopija u XII veku," p. 201, with sources.

25 Prvovenčani, op. cit., p. 173; J. Kalić, "Srpska država i Ohridska arhiepiskopija u XII veku," p. 204.

26 This second baptism could have taken place close to the years 1158-1159, mentioned by Prvovenčani in a chapter of the Vita prior to the story of taking control over the region of Rasina and Reke; Prvovenčani, op. cit., p. 172; J. Kalić, "Srpska država i Ohridska arhiepiskopija u XII veku," p. 200.

ment into which he had been cast by his brothers but ultimately also a signum of his steadfastness in remaining the Empire's key man in the region.[27]

The founding of Studenica could very well also be deeply dependent on events resulting from the specific and mutually significant relation between Nemanja and institutions representing Byzantine power in the Balkans, first and foremost the Archbishopric of Ohrid. It is interesting to note that, chronologically, according to the sources, i.e. the Vita of St. Symeon by Stefan Prvovenčani, the founding and building of Studenica issues after the council held at Ras against Bogumil heretics, called by Nemanja and held in the presence of Bishop Eusthatios of Ras, whom the sources refer to as "his own archiereos".[28] It is highly significant to note that surpressing the Bogumil heresy was among the top priorities in the diocese of Ohrid already during the office of John Adrian Komnenos.[29] By calling together this council and by the fierce slaying of the enemies of Orthodoxy and Byzantine *taxis* which ensued, Nemanja would, thus, be once again confirmed as a soldier of true faith, a "holy warrior", a new St. George slaying the dragon of heresy, displaying the very virtues for which he was recommended by John Adrian Komnenos to the emperor Manuel I. Therefore, it appears that Studenica could indeed have been founded by Nemanja, in correlation with the interests of the bishops of Ras with whom he had noticeably good relations, as an axial point in establishing the triumph of orthodoxy against the Manichean heresy of the Bogumils on the territory of the Bishopric of Ras.

Studenica began its life and received its initial identity under one set of circumstances and was finalized under an entirely different political and ecclesiastic situation. Still, its intrinsic symbolism of the triumph of orthodoxy functioned unmistakably in conveying its message in both sets of circumstances and was, what's more, easily and naturally transposed from one period of its history to the next. The initial idea and act of raising a church dedicated to the Virgin, thus materializing iconic proof of the dogma of incarnation, was subsequently only amplified by the planting therein (1198 or possibly earlier) of the Holy Wood, thus defining Nemanja's lands, or the territory under his control, and at the same time the Bishopric of Ras, as a true Paradise with the lifegiving tree as its axis, a New Jerusalem, while likening the *ktetor* to the archetypal imperial personages associated with *inventio* and *exaltatio Crucis*,

---

27  On Nemanja's building activity as reflection of his status in the Byzantine sphere in the Balkans see I. Stevović, "Istorijski izvor i istorijskoumetničko tumačenje: Bogorodičina crkva u Toplici," passim; J. Kalić, "Srpska država i Ohridska arhiepiskopija u XII veku," passim.

28  Prvovenčani, op. cit., p.172.

29  J. Kalić, "Srpska država i Ohridska arhiepiskopija u XII veku," p. 206.

Constantine and Heraclius.[30] This identity was around the turn of the XIII century easily employed as the basis of self-representation and construction of identity of Nemanide dynastic legitimity and continuity and as the nucleus from which sprang the autocephalous Serbian church, which became the new natural and, what's more, *legitimate* defender of true faith, taking over that position, even literally, from the Archbishopric of Ohrid. Long after the establishing of the autocephalous church, Sava remained constant in maintaing this line of domination of Orthodoxy and a champion of true faith – ultimately presented in his Serbian version of the Synodicon of Orthodoxy proclaimed at Žiča in 1221.[31]

What's more, it appears, just as it must originally have been intended to, that the glistening white marble with gray-blue veining of the facades of the church of the Virgin at Studenica, with its ancient and ever present learned symbolism of the waters of the primaeval Okeanos frozen by primordial cold whereby light, the active principle of the Logos, was frozen into its very fabric,[32] embodied perfectly the message of the triumph of orthodox belief in the incarnation and the triumph of the Cross. Within the new set of circumstances and new meanings invested in Studenica following the watershed year of 1204, the translation of Nemanja's body in 1207 and the establishing of his cult therein as the pivot of Serbian identity of state and church, this perennial symbolism of the refined, sophisticated material, activated in synergy with the sacral contents of Studenica, could, in the eyes of the *ktetors*, Sava above all, procure an image which was to suggest that this Serbian New Jerusalem echoes the ultimate universal Constantinopolitan example of a New Jerusalem, the church of the Virgin of Pharos,[33] precisley for the purpose of displaying the appropriation of dogmatic and ideological ideas contained therein.[34]

---

30 On Nemanja as a new Constantine see S. Marjanović-Dušanić, *Vladarska ideologija Ne-manjića. Diplomatička studija* (Belgrade, 1997), esp. pp. 287-302.

31 D. Bogdanović, "Preobražaj srpske crkve," *Istorija srpskog naroda* I, pp. 315-327.

32 On the symbolic meaning of marble see F. Barry, "Walking on Water: Cosmic Floors in Antiquity and the Middle Ages," *Art Bulletin*, Vol. LXXXIX, No. 4, Dec. 2007, pp. 627-656, esp. p. 635.

33 On the New Jerusalem symbolism of the imperial church of the Virgin of the Pharos from the Great Palace of Constantinople see A. M. Lidov, "Cerkov Bogomateri Farosskoi. Imperatorskii hram-relikvarii kak konstantinopolskii Grob Gospoden," *Vizantiiskii mir: iskusstvo Konstantinopola i nacionalnie tradicii. K 2000-letio hristianstva* (Moskva, 2005), pp. 79-108.

34 Some of the questions raised by this (re)examination of Studenica are further discussed in J. Erdeljan, "Studenica. An identity in marble," *Zograf* 35 (2011), pp. 93-100; ead., "Studenica. All Things Constantinopolitan," *Symmeikta. Collection of Papers in Honor of the 40th Anniversary of the Institute for Art History, Faculty of Philosophy, University of Belgrade*, I. Stevović, ed., Belgrade 2012, 93-101.

# Serbian and Byzantine Coinage

*Vujadin Ivanišević*

The coinage in medieval Serbia drew on the achievements of the Byzantine monetary system. The first issues of the Serbian king Stephen Radoslav (1228-1234) were modelled after those of the Thessalonian Empire (Fig.1). These issues, albeit short-lived – they were minted for a few years only – demonstrate the importance Byzantine coins enjoyed in the central Balkans in the early 13th century, as they had been the principal legal tender in the region for many preceding centuries. The changes that occurred in the early 13th century when the economic axis moved from west to east resulted in the first place in the penetration of Central European silver coins, such as those minted for Hungarian kings, Friesacher pfennigs and Venetian grossi. The Venetian currency shortly took the place of the weakened Byzantine coins. Towards the end of the 13th century, under the new and changed circumstances, medieval Serbia started anew to mint its coins following the model of the Venetian silver grosso (Fig. 2.1-2). The system was due to the predominance of the Venetian currency on the Balkan market and Serbia's wealth in ores. This wealth came from the exploitation of the silver ore. The production of this precious metal gained momentum in the late 13th century. Although the Serbian and Byzantine coinage parted company, other ties subsisted: spiritual – because the Serbian mints took over the images from the Byzantine coins – and economic as reflected in the distribution of Byzantine coinage in the Serbian territory. This flow followed two different directions due to the diverse degrees of monetarisation of the Balkan market. The first was the area of the weak circulation of Byzantine coins within Serbian territories, and the second the area of intensive circulation of Byzantine issues in newly conquered territories, notably Macedonia.

The first issues of coins in medieval Serbia are associated with King Stephen Radoslav who had close spiritual and political ties with the Thessalonian Empire. From the typological and metrological point of view, his issues are based on the contemporary issues in Thessalonica. His monetary system was thus based on bimetallism – he minted electrum, or, more accurately, a silver aspron trachy for the market at large and billon, that is a copper aspron trachy, for the local use.[1] It was based on the Byzantine system, which played a

---

1    V. Ivanišević, *Novčarstvo srednjovekovne Srbije* (Belgrade, 2001), pp. 87-89.

predominant role as demonstrated by numerous finds of Byzantine coins in the Ras[2] and Braničevo fortresses.[3]

Like the metrological basis, the iconographic images were also taken over from the coins of the Thessalonian Empire. Thus, the issue of King Stephen Radoslav with the representation of St. Constantine and the king is a direct copy of Manuel Ducas' (1230-1237) issue. We may also mention the reverse representation on the silver aspron trachy of King Stephen Radoslav, showing the king being blessed by Christ, modelled after Theodore Ducas (1227-1230) and Manuel Ducas's coins (Fig. 1). Some details on the Serbian coins, such as stemma, maniakion, loros, divitision as well as others, were directly taken over from the issues of the Thessalonian Empire. It is quite certain that the die cutters came from Thessalonica. It is possible that Thessalonian craftsmen and minters directly participated in the organisation of minting in Serbia.[4]

The production of coins during the reign of King Stephen Radoslav was limited to their circulation in the territory of Serbia, and the issues were concentrated mostly in the area of Ras, notably the fortress of Ras.[5] A find of a trachy from Sarda in the close vicinity of Scutari attests to the fact that this coinage may have been invested with broader significance.[6]

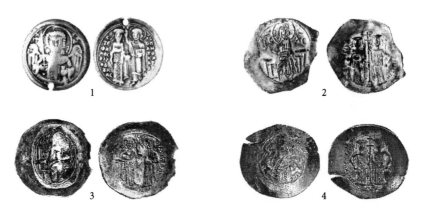

*Fig. 1.1-2: Trachea of Stephen Radoslav; Fig. 1.3: Trachy of Theodore Duca; Fig. 1.4: Trachy of Manuel Duca*

2  V. Ivanišević, "Nalazi novca iz tvrđave Ras," *Tvrđava Ras*, ed. M. Popović (Belgrade, 1999), pp. 417-436.
3  V. Ivanišević, "Vizantijski novac (1092-1261) iz zbirke Narodnog muzeja u Požarevcu," *Numizmatičar* 14 (1991), pp. 57-72.
4  V. Ivanišević, *Novčarstvo*, pp. 87-88.
5  V. Ivanišević, "Nalazi," pp. 417-436.
6  H. Spahiu, "La ville haute-médiévale albanaise de Shurdhah (Sarda)," *Iliria* 5 (1976), p. 158, pl. VII.3.

After the deposition of King Stephen Radoslav, the minting of coins in Serbia stopped, only to be renewed, as we have said, several decades later under King Stephen Dragutin (1276-1282/1316). That time was marked by major economic changes and the development of trade in the Balkan Peninsula. The beginnings of mining, and particularly the exploitation of the silver ore, prompted the political and economic ascent of Serbia. The development of the monetary market and a shift towards silver money and the new denomination: silver grosso were one of the aspects of these changes.

These changes in the spheres of influence of the monetary systems in the Balkans are best illustrated by written documents. Byzantine gold coins – hyperpyra – played an important role on the coast as early as the first half of the 13th century. A deal from 1232 states that Ragusa shall be bound to pay to Venice an annual due of 100 old gold *perperi – yperperos aureos ueteros recti ponderis centum.*[7] An identical contract between the two cities was concluded in 1236. There is no doubt that the reference is to hyperpyron – the Byzantine gold currency used for all major monetary transactions. In the latter half of the 13th century, its role was taken over by the Venetian grosso, but the memory of the earlier monetary system remained embossed in the name of the money of account – perpero. In 1252 already, Ragusa paid its due of 112 gold perperi in Venetian grossi.[8] The Venetian grosso became the principal legal tender on the coast, and its influence spread gradually to the hinterland and further in the Balkan Peninsula.

When King Stephen Dragutin renewed the coinage, he founded it on the Venetian grosso, one of the most stable medieval denominations.[9] The significance of this issue is demonstrated by the fact that in the early 14th century the Venetian grosso was also the model for the new denomination of the Byzantine silver coin – basilicon (Fig. 2.1 and 3).

Basilicon and Serbian dinar, notwithstanding their common roots and metrological basis, belonged to two different monetary systems. The Byzantine and the Serbian monetary systems remained separate until they both disappeared altogether two centuries later. Nevertheless, numerous iconographic images and representations on the Byzantine currency, which enriched the Serbian coinage with new subjects and messages, persisted as a point of contact between them.

7   J. Tadić, *Pisma i uputstva Dubrovačke republike* I (Belgrade, 1935), 23, no. 18.

8   T. Smičiklas, *Diplomatički zbornik kraljevine Hrvatske, Dalmacije i Slavonije IV* (Zagreb, 1906), p. 498.

9   V. Ivanišević, *Novčarstvo*, pp. 72-73, pp. 90-91.

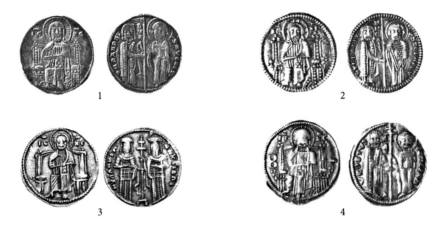

*Fig. 2. 1: Grosso of Enrico Dandolo; Fig. 2.2: Dinar of Stefan Dragutin;*
*Fig. 2.3: Basilicon of Andronicos II and Michael IX; Fig. 4.4: Dinar of Stephen Milutin*

The picture of the enthroned Christ, the chief representation on the Serbian currency with all its symbolism, was deeply rooted in individual beliefs. It was taken over from the Venetian grosso but it drew its roots from the Byzantine iconography and that is why it remained on the Serbian coinage for a long time (Fig. 2.1, 2 and 4). This image was featured on Byzantine coins ever since the time of Basil I.[10]

In addition to it, one also finds the picture of the bust of Christ blessing and holding the akakia. It was on an issue of a trachy minted for King Stephen Radoslav. This representation is of Byzantine origin and can be seen on anonymous folles of group G, attributed to the coinage of Romana IV (1068-1071), from as early as the 11th century.[11] This motif was subsequently represented on the coins of the Bulgarian ruler Constantine Asen (1257-1277).[12] Christ giving his blessing on dinars minted by Tsar Stephen Dušan (1331-1355) is also found in combination with figures of two angels to one side.

The representation of a ruler receiving first the banner and then the cross from St. Stephen, the patron of the Nemanjić royal dynasty, occupied an important place in the Serbian coinage (Fig. 2.2 and 4). It was a favourite representation on the coins and it would continue as such as long as the kingdom

---

10   P. Grierson, *Catalogue of the Byzantine Coins in the Dumbarton Oaks Collection and in the Whittemore Collection, Leo III to Michael III, 717-867*, Vol. III.1 (Washington D.C., 1973), pp. 146-154, pl. XXX.1-2.

11   P. Grierson, *Catalogue*, p. 169 and pp. 692-694, T. LXI.G.

12   J. Jurukova, V. Penčev, *Balgarski srednovekovni pecati i moneti* (Sofia, 1990), p. 85, type I-II.

itself, but it can also be found later, even if seldom. The symbolism of this representation reflects the perception of the ruler's place on earth and his conformity with the heavenly authority. It draws its roots from the Byzantine iconography which often represents rulers and their patrons. This recognisable symbolism and the idea of the authority are clearly demonstrated already on the first Serbian coins of King Stephen Radoslav.

The image of a ruler standing and holding the sceptre is also of Byzantine origin. It was minted during the reigns of Stephen Dragutin and Stephen Vladis-lav II (1316/1321-c.1325). In the Byzantine coinage the standing figure of a ruler was the favourite motif ever since the time of the Macedonian dynasty and in particular those that succeeded it. We find it in Bulgaria on the coins of Theo-dore Svetoslav (1300-1322), which were very similar to Serbian issues.[13] The representation of the crown with lilies and the absence of akakia on the coins of Stephen Dragutin (Fig. 3.1) and Stephen Vladislav II (Fig. 3.2) , in contrast to the issues of Theodore Svetoslav, constitutes a clear indication of Western influences (Fig. 3.3).

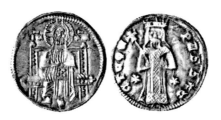

*Fig. 3.1: Dinar of Stephen Dragutin*

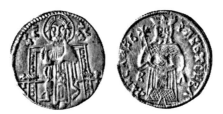

*Fig. 3.2: Dinar of Stefan Vladislav II*

---

13   J. Jurukova, V. Penčev, *Balgarski*, pp. 99-106.

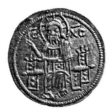
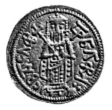

*Fig. 3.3: Coin of Theodore Svetoslav*

One of the outstanding representations on the coinage of Tsar Stephen Dušan is that of a ruler standing as he is crowned by angels (Fig. 4.1). At times, to the left and to the right of his feet, are lion protomes as the throne adornment. The ruler wears the stemma and the sakkos, maniakion and diadem, holding the sceptre with the cross in his right hand and the akakia in the left hand. The iconography was taken over from the mural painting in the Nemanijić genealogy compositions in Gračanica and Peć. This representation clearly stresses the divine origin of the imperial authority and the act of coronation itself.[14] Similar representations are found in the Byzantine coinage where the emperor is commonly crowned by Christ and the Mother of God. Both iconographic representations are also found on the first Serbian coins – trachea of King Stephen Radoslav.

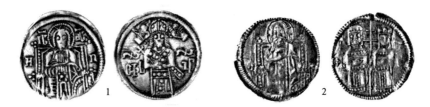

*Fig. 4.1, 2: Dinars of Stephen Dušan*

The representation of the emperor and the empress holding a cross together is indubitably of Byzantine origin (Fig. 4.2). It is a common Byzantine iconographic image on the coins, clearly emphasising the holy origin of the imperial family's authority.[15] It draws its roots from the ancient coinage. In the Middle Ages, it represented the favourite motif in the coinage of the European

---

14  S. Marjanović-Dušanić, *Vladarske insignije i državna simbolika u Srbiji od XIII do XIV veka* ( Belgrade, 1994), p. 91.

15  S. Marjanović-Dušanić, *Vladarske*, p. 93.

East. It is found on relatively early coins of the Bulgarian emperor Michael Shishman (1323-1330).

Epigraphic types of issues with inscriptions in several lines and a monogram on the reverse were introduced during the same period (Fig. 4.3). Both types were regularly minted until the end of the Serbian state in the mid-15th century. Dinars with inscriptions several lines long appeared first as the prototype. They underwent several variations due to the decreasing weight and size of the flan resulting in shorter inscriptions as well. On the other hand, the monogram appeared only sporadically as, for instance, on issues of imperial half-dinars.

Serbian minters also took over some details from the Byzantine coins and combined them with representations typical of other coinages. The half-dinar of Tsar Stephen Dušan, for instance, features the ruler's head with a crown – the 'stemma'. We are not aware of such representations in the Byzantine and Bulgarian coinages. It was taken over from the Hungarian coins, as demonstrated by the pictures of the crowned ruler common on Charles Robert's and Louis I coins.[16] It is not a faithful copy, as the Western crown with 'fleurs de lys' on the Hungarian coins was replaced by a stemma, the Byzantine-type crown, on the Serbian issue (Fig. 4.4).

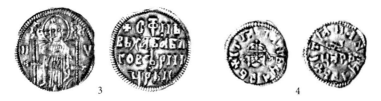

*Fig. 4.3: Dinar of Stephen Dušan; Fig. 4.4: Half-dinar of Stephen Dušan*

The Byzantine influence on the Serbian coinage was at times very pronounced. One of the most outstanding examples was the issue of Empress Helena (1360-1365), the widow of Tsar Stephen Dušan and mother of Tsar Stephen Uroš (1355-1371), who governed the province of Serres after the death of Tsar Stephen Dušan. At the outset she did not rule independently, but after 1360 she became an independent ruler – despina. In 1365 Despot Uglješa (1365-1371) took her place. During her short reign between 1360 and 1365, three types of dinars were minted. The first issue stands out – it shows King Vukašin (1365-

---

16  L. Huszár, *Münzkatalog Ungarn, von 1000 bis heute* (Munich, 1979), pp. 79-87: Charles Robert denarii nos. 449, 459, 473 and 491 and parvi nos. 461-462, 467 and 493; Louis I denarii no. 526 and oboli 527.

1371) on a horse on the obverse and a helmet with a headband surrounded by an inscription in Greek on the reverse (Fig. 4.5).

Feudal issues in Serbia started in mid-14th century and enriched the Serbian coinage with new contents. Despot Uglješa's coins reflected parallel Byzantine and West European influences. The best example of this is Despot Uglješa's dinar which on the obverse shows facing Tsar Stephen Dušan, haloed with a stemma, wearing sakkos, maniakion and diadem and holding the sceptre with the cross in his right hand and the akakia in the left hand. It is one of the most "impressive" representations on the Serbian coinage. On the reverse is a cross with 'fleurs de lys' ornaments at ends, typical of West European issues (Fig. 4.6).

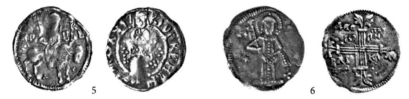

*Fig. 4.5: Dinar of Empress Helena; Fig. 4.6: Dinar of Uglješa*

Coins with the representation of a two-headed eagle are also worth mentioning, as they were the most important issue of Despot Uglješa (Fig. 4.7). They also draw their roots from the Byzantine circle and represent the insignia of the Despot;[17] this is the first time the two-headed eagle appears on the currency of Serbian rulers. This motif will appear later within the same context on issues of Despot Stephen Lazarević (1389-1427) (Fig. 4.8) and Djuradj Branković (c.1402-1456).

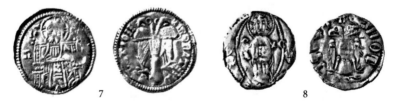

*Fig. 4.7: Dinar of Uglješa; Fig. 4.8: Dinar of Stephen Lazarević*

---

17   S. Marjanović-Dušanić, *Vladarske*, pp. 116-117.

In the latter half of the 14th century, Serbian coins move away from Byzantine models and look for their motifs primarily in Central European coinages. The Serbian and the Byzantine monetary systems parted company due, evidently, to the weakening of the political and economic power of the Byzantine Empire.

One of the aspects of the relationship between the Serbian and the Byzantine coinages is the parallel circulation of coins, especially in Serbia's newly conquered territories in Macedonia. The explanation for this phenomenon could be the uneven economic development of different parts of the Serbian state. The mono-metal monetary system, based on Serbian silver coins, prevailed in its central and northern areas. On the other hand, on the East Adriatic coast, its immediate hinterland and in southern areas, which came under Serbian rule during the 14th century, the monetary system was more advanced and meant a much more complex circulation of coins with gold, silver and especially copper denominations. The principal denomination of gold coins was the Venetian ducat, while the Byzantine hyperpyron appeared sporadically.

The largest number of transactions was in Venetian ducats. According to Ragusa sources, the ducats were widely used since the fourth decade of the 13th century and continued as the chief legal tender in the centuries that followed. Some payments were in Florentine ducats, albeit to a much lesser degree. They are mentioned mostly in documents from the third to the sixth decade of the 14th century. During this period, we also find references to the Byzantine gold issues. The gold Paleologian hyperpyra circulated in the Balkans, but much less than the Nicaean gold, notably the issues of John III Ducas, called Vatatzes (1221-1254).

Three gold coins of Andronicos II and Michael IX (1294-1320), Andronicos II (1282-1328) and Andronicos III (1328-1341) in the collection of the National Bank of Macedonia in Skopje and three other of Andronicos II in the collection of the National Museum in Belgrade attest to the circulation of the Byzantine money in the Central Balkans. In addition to these coins, the National Museum in Belgrade also has in its collections a rare hyperpyron of John V Paleologos and John Cantacuzenos (1347-1353) and this also indicates the circulation of gold Byzantine currency, albeit to a much lesser extent. The principal monetary denominations in circulation were Serbian silver dinars and Venetian silver grossi.[18]

On the East Adriatic coast, partly under the Serbian rule, an important place in the circulation belonged to copper coins used primarily in day-to-day transac-

---

18   V. Radić, V. Ivanišević, *Vizantijski novac iz Narodnog muzeja u Beogradu* (Belgrade, 2006), p. 72.

tions. The importance of copper coins is confirmed by a Ragusa document of 1294. Because of the large quantity of imitative coins this edict prohibits the use of 'staminum *de Dyrachio et Romania'*, follari *'de Armenia et Turchia, novos et veteres'* and copper coins without inscription and picture, coins with a hole in the centre called *'capucie'* and new follari copying old models.[19] The presence of small change for daily use from other states and cities can be interpreted as the pursuit of gain by merchants exchanging copper coins for more valuable silver ones. Autonomous cities on the East Adriatic coast – Ragusa, Kotor, Bar, Ulcinj, Durres and Svač – had their own copper money. Of them, two communes, Kotor and Ulcinj minted coins with the names of Serbian rulers – tsars Stephen Dušan and Stephen Uroš V. These coins were minted for local use, but also found their way to more remote areas. There are recorded finds of follari of Tsar Stephen Uroš V in Bulgaria and also in Macedonia.

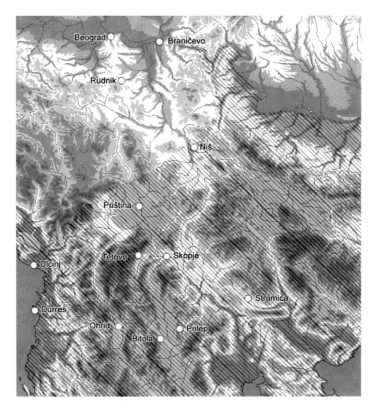

*Map 1: Area of circulation of Byzantine coins*

19   M. Rešetar, *Dubrovačka numizmatika* I (Sremski Karlovci, 1924), pp. 481-483.

On the other hand, Palaiologian copper issues, mostly those from the Thessalonica mint and, to a lesser extent, the mint in Constantinople, played an important role in the circulation in Serbia's newly conquered lands in Macedonia. This area was conquered after 1284 and bordered on Strumica, Prosek, Prilep and Ohrid. These military and political changes resulted in a significant penetration of the Serbian silver coins replacing Byzantine issues of higher value. At the same time, Byzantine copper coins remained the currency for daily use. This phenomenon is demonstrated by numerous finds of copper trachea and stamena of Michael VIII (1258-1282), Andronicos II, Andronicos II and Michael IX and Andronicos III in Ohrid, Prespa, Pelagonia, Strumica, Skopje and territories to the northwest of Tetovo. Particularly significant for our purpose are the coins found during the recent archaeological excavations of the fortress in Skopje. There were numerous Byzantine stamena, which were in parallel circulation with Serbian coins and copper follari of East Adriatic cities, especially from the Ulcinj mint.

The central and northern lands of the Serbian state offer a completely different picture. Here, the influence of the Byzantine currency declined as early as the first half of the 13th century and thereafter was present only sporadically. In some areas the circulation of Byzantine coins was cut short completely. Its influence persisted partly only in north-eastern parts of the country and along the Danube which was still an important route of communication (Map 1). The necropolis in Knjaževac brought to light a fragmented Thessalonian trachy of Andronicos II, whilst a tetarteron of Andronicos II and Michael IX struck in Thessalonica and a trachy of Andronicos III from the same mint were discovered in a settlement by the Porečka River near Donji Milanovac. The circulation of these issues has to do, perhaps, with the immediate vicinity to Bulgaria where copper denominations played an important role in circulation and thereby in exchange. This is best evidenced by a large hoard of copper coins discovered in Vidin. The hoard contained some 1365 coins, of which the majority were Palaiologian issues, those of Bulgarian rulers, John II Orsini, the Epirote despot (1323-1335), imitations of coins, copper issues of Tsar Stephen Uroš V from the Ulcinj mint and issues of the Golden Horde, etc.[20]

The overall decay of the Byzantine power towards the end of the 14th and in the beginning of the 15th century led to the shrinking of the area of circulation and influence of the Byzantine currency. The Serbian and the Byzantine systems separated, but both ceased to exist after a short while in the aftermath of the Ottoman conquests.

---

20   V. Penčev, "Kolektivna nakhodka s medni (bilonovi) moneti ot XIII-XIV v. ot Vidin," *Numizmatika i epigrafika* 1 (2003), pp. 129-159.

# Principles of the Representation of the Founder's (*ktetor's*) Architecture in Serbian Medieval and Byzantine Art

*Čedomila Marinković*

Representations of a church building in the founder's portraits in Serbian medieval and Byzantine art are present through a wide range of formulae. It is, therefore, difficult to establish boundaries within which those representations can be regarded as realistic. The question arises as to the measure in which the painted architecture in the *ktetor's* hands represents the real and in which the ideal architecture? Is it possible to single out the elements that are common features in the *ktetor's* representation of architecture, to identify certain *topoi* in the painted *ktetor's* architecture?[1] Are there common symbolic or decorative elements present, and can one identify those elements that are unambiguously realistic – painted according to the real architecture? Is it, therefore, possible to detect a certain realism in the representation of architecture on *ktetors'* portraits? If so, to what extent is that realism expressed, and in what way, how constant is it as a principle, and can traces of a certain development be established, leading to the more immediate establishment of a relation between the painted church and the actual, finished construction that served as its model?

## I.  Towards the Realism of the *ktetor's* Representation – Methodological Limitations

When establishing the similarities between the church's representation and its real prototype, it is necessary to face a series of limitations that prevent drawing a reliable conclusion. Since we are dealing with medieval painting, it is difficult

---

1   The term *topoi*, common features (κοινοί τόποι, *loci communes*) is here used with the meaning it conveyed in Byzantine and Serbian medieval literature. Cf. Đ. Trifunović, *Azbučnik srpskih srednjovekovnih književnih pojmova* (Terminological Dictionary of Serbian Medieval Literature) (Belgrade, 1990), pp. 199-221. On the rhetoric and function of common features in Byzantine and Serbian Medieval literature cf. N. Radošević, "Danilo II i vizantijska dvorska retorika" (Archbishop Danilo II and Byzantine Court Rhetorics), *Arhiepiskop Danilo II i njegovo doba* (L'Archevêque Danilo II et son époque), ed. V. J. Đurić (Belgrade, 1991), pp. 245-251, esp. 249-250.

to establish the meaning of the term realistic.[2] And, as this refers to very important theoretical topics for the history of Byzantine and Serbian medieval art, which largely go beyond the scope of this paper, we shall this time settle only for their outlines. The first difficulty in defining the realism of painted architecture in the *ktetor's* hands in Serbian medieval and Byzantine art is the cultural and historical framework that produced the given art. An understanding of art and the ways in which it is expressed cannot be separated from the society that uses a certain visual language, and the Byzantines believed that they were living in the focus of various supra-sensual representations.[3] In Byzantine culture, in which the icon, the Eucharist and relics were viewed as real and present, and where the liturgy and court ceremony represented the general idea of the connection between the heavenly and earthly worlds, the basic idea of art was to transcend reality, in the desire to present the general, eternal and archetypal.[4]

---

2    The problem of realism in Byzantine culture is discussed in a very provocative way by H. Franses, *Symbols, Meaning, Belief: donor portraits in Byzantine art* (unpubl. Ph.D. Thesis, London University [1992], p. 207, p. 210. He warns that this problem in Byzantine art is very complex and depends on the conceptual framework of each individual work.

3    A. Grabar, "La répresentation de l'intelligible dans l'art byzantin du Moyen Age," *L'Art de la fin de l'Antiquité,* vol. I (Paris, 1968), p. 58. This viewpoint is especially pronounced in the work of St. Maxim the Confessor (*Mystagogia, Patrologiæ Græcæ 2,* ed. J. P. Migne [Paris, 1889], vol. 91, p. 669), who was of the opinion that the sensory and intelligible world in its wholeness represents a cosmic church and that the services of this world continuously imitate the liturgy of the angelic forces (Migne, op. cit., p. 685).

4    The Byzantine understanding of the reality of the icon culminated in unusual customs in which the icon took over the inherencies of a real person. Some of these customs directly conditioned the creation of the iconoclasm. Although this is the common feature of Byzantine theology and art, and therefore the subject of numerous studies not specifically cited here, we would like to indicate an especially interesting study by Charles Barber ("From Transformation to Desire: Art and Worship after Byzantine Iconoclasm," *Art Bulletin* 75 (1993), pp. 7-16), who discusses the status of the art object after the iconoclasm. Scientific interest in the meaning and importance of miraculous icons and relics in Byzantine daily life has been especially emphasized lately. Very significant studies, collections of papers and scientific meetings have been devoted to icons and relics. Cf. I. Kalavrezou, "Helping Hands for the Empire: Imperial Ceremonies and the Cult of Relics at the Byzantine Court," *Byzantine Court and Culture from 829 to 1204* (Washington D. C., 1997), pp. 53-79. Especially significant work in this respect was done at the Research Centre for East-Christian Culture in Moscow that – thanks to its initiator, organizer and theoretician Aleksei Lidov – published a number of collections of papers that are essential when studying the listed topics. Cf. A. Lidov (ed.), *Čudotvornaja ikona v Vizantii i Drevnej Rusi* (Miracle-working Icons in Byzantium and Old Russia) (Moscow, 1994); idem (ed.), *Relikvii v iskusstve i kulture vostočnohristianskogo mira* (Relics in the Art and Culture of the Eastern Christian World) (Moscow, 2003). A collection of papers by

Thus, its realistic perception was possible only with spiritual eyes.[5] That feature clearly distinguished Byzantine art from the art of Antiquity, which it had inherited, as well as from the art in the epochs after the fall of Byzantium.

The other problem is the mode of transfer between model and actuality in medieval times. It is very complex and frequently based on a rather wide concept of the similarity between the model and its replica. In medieval art, the copy was not understood mimetically: only the basic idea of the model was adopted – sometimes reduced to a topographical indication – but not necessarily the actual morphological elements. Besides, the model was never imitated *in toto*, but only partially.[6] The digression of the painted ktetorial architecture from the appearance of the real building, and their only general similarity, could be the consequence of the painter's lack of skill – his inadequate ability to convey the building's characteristics – as well as of his adherence to a certain cultural and stylistic circle. It is interesting that those *ktetors'* representations which

---

   Danica Popović from Serbian scientific literature on this topic was published recently. Cf. D. Popović, *Pod okriljem svetosti* (Under the Auspices of Sanctity) (Belgrade, 2006).

5   A. Grabar, "Plotin et les origines de l'esthétique médiévale," *Cahiers archéologiques* 1 (1946), pp. 15-34. The way of representing the extra-sensual is the central problem of the Byzantine understanding of beauty, especially during the epoch of the iconoclasm. From the copious literature on this topic we would like to indicate the following: A. Grabar, "Le message de l'art byzantine," *L'art Byzantin, l'art Européen* (Athens, 1964), pp. 49-63, esp. 59; idem, "La représentation de l'intelligible dans l'art byzantin du Moyen Age," *L'Art de la fin de l'Antiquité*, vol. I (Paris, 1968), pp. 51-63; idem, "Byzance. Symbolisme cosmique et monument religieux," *L'Art de la fin de l'Antiquité*, vol. I (Paris, 1968), pp. 71-73; J. Majendorf, *Vizantijsko bogoslovlje* (Byzantine Theology) (Kragujevac, 1985), p. 11; V. N. Lazarev, *Istorija Vizantijskoj živopisi* (Moscow, 1986), pp. 15-20; K. Kavarnos, "Estetsko ispitivanje vizantijske umetnosti" (Aesthetical reconsideration of Byzantine Art), *Gradac 82-84* (Čačak, 1988), pp. 84-90; V. Bičkov, *Vizantijska estetika* (Byzantine Aesthetics) (Belgrade, 1991), pp. 128-192; C. Mango, *Byzantium. The Empire of the New Rome* (London, 1994), pp. 151-166. On understanding the beauty in Serbian medieval art cf. Sv. Radojčić, "Oblik i misao u starom srpskom slikarstvu" (Form and Meaning in Old Serbian Painting), *Uzori i dela starih srpskih umetnika* (Belgrade, 1975), pp. 253-262.

6   R. Krautheimer, "Introduction to an Iconography of Medieval Architecture," *Journal of the Warburg and Courtauld Institutes* 5 (1942), p. 13; V. Korać, "Sv. Sofija u Beneventu. Uzor i ostvarenje" (St. Sophia in Benevento. Model and Accomplishment), *Zbornik Radova Vizantološkog Instituta* 33 (1994), pp. 37-52; A. Davidov-Temerinski, "Le modèle de l'église que les apôtres Pierre et Paul tiennent ensemble," *Cahiers Balcaniques* 31 (2000), p. 47, fn. 36 (with especially detailed literature on this topic). The most unusual example of this principle known to us is the transmission of the basic idea of the Constantinopolitan Ag. Sophia into a morphologically completely different church with the same name in Benevento. Cf. Korać, loc. cit.

show the highest degree of realism are most often connected with monuments whose *ktetors* came from the highest social strata. In Serbia, Armenia, Georgia and Bulgaria they usually came from the ruling dynasties. In Byzantine and Serbian medieval art, such monuments are stylistically linked with the art of Constantinople, in which the churches were very realistically depicted.[7] In contrast, in the case of monuments in which the *ktetor's* architecture is generalized or completely unrecognizable, one of the most frequent reasons was the distance from the main stylistic trends of the epoch.[8] However, one must be very careful when drawing conclusions, since the lofty social status of the *ktetor* did not necessarily guarantee the highest artistic quality, either of the actual construction itself or the art work.[9] The fourth difficulty is the technical manner of artistically conveying the model. The technical manner medieval artists used to convey their models has not yet been thoroughly studied, although the attention of scholars has recently focused on this topic.[10] In Western Europe, there are some preserved written sources that deal with the art of the period, for instance, the treatise by the monk Theophilus, *De diversis artibus,* from the beginning of the 12th century,[11] as well as the collection of drawings by Villard de Honnecourt.[12]

---

7　This is the case with examples from Ivanovo (Church), Boïana, Mistras (Theotokos Peribleptos), Volotovo, Gračanica and Vardzia.

8　This is the case with examples from Bačkovo, Kalotino, Cappadocia (Belisirma kirk dam alti kilise) and from Cyprus (Moutoulla). Many authors have expressed a similar opinion: the distance from the main streams of style is the cause of the absence of greater realism in representations of ktetorial architecture. With regard to Bačkovo and Kalotino, Grabar is of the same opinion (*La peinture religieuse en Bulgarie* [Paris, 1928], pp. 284, 290). He thinks that Kalotino is rustic in style which retains explicitly archaic artistic patterns. Similar opinions were expressed by Nicole and Michel Thierry (*Nouvelles églises rupestres de Cappadoce* [Paris, 1963], p. 221) when they referred to the church in Belisirma in Cappadocia. J. Stylianou ("Donors and Dedicatory Inscriptions, Supplicants and Supplications in the Painted Churches of Cyprus," *Jahrbuch der Österreichischen Byzantinischen Gesellschaft* 9 (1960), pp. 98, 103), on the paintings in the church of Panaghia tou Moutoulla on Cyprus, talks about the obvious inability of the artist to paint according to nature, of which one can learn the most from ktetorial architecture.

9　E. Kitzinger ("Some reflections on portraiture in Byzantine Art", *Zbornik Radova Vizantološkog Instituta* 8/1 [1963], p. 186) and I. Spatharakis (*The Portrait in Byzantine Illuminated Manuscripts* [Leiden, 1976], p. 256) are of the opinion that the artist's skill influences the realism of representation. Regarding the problem of centre and periphery, the collection of papers *Byzantina –Metabyzantina. La péripherie dans le temps et l'espace*, ed. P. Odorico (Paris, 2003) is particularly interesting.

10　R. Scheller, *Exemplum: Model-Book Drawings and the Practice of Artistic Transmission in the Middle Ages (Ca. 900 - Ca. 1470)* (Amsterdam, 1995).

11　Ch. Dowell (ed. and transl.), *Theophilus: The Various Arts* (London, 1961).

12　Th. Bowie (ed.), *The Sketches of Villard de Honnecourt* (Bloomington, 1959).

With the exception of painters' manuals – *hermeneia* – which were compilations from later periods, such technical instructions and collections of drawings have never been found for Byzantine art. And, according to Winfield's research, such collections of drawings never existed in Byzantium.[13]

The regional characteristics of the *ktetors'* scenes, sometimes even the material[14] with which such scenes were produced, present an obstacle for drawing a general conclusion regarding the realism in the representation of the *ktetor's* scene.

## II.    Representing the *ktetor's* Architecture

Leaving aside the aforesaid theoretical issues, let us dwell on the topic that is the central part of our discussion – on the ways in which the *ktetor's* architecture was actually presented. In Byzantine and Serbian medieval art, the basic function of the founder's portrait with the representation of a church building, which was an important part of the iconographic program of every church, specially prescribed by the founder's right, was votive. A painting, illustrating the founder holding his endowment, expressed in pictorial form the type of founder's right that the charter or *typikon* defined in written form. The custom of writing a founding charter on the wall of a church right beside the founder's portrait leads to the assumption that the founder's portrait with the church was a certain type of visual equivalent to the charter as a legal act.[15] This also seems to be the ex-

---

13    D. Winfield, "Middle and Late Byzantine Wall Painting Methods: A Comparative Study," *Dumbarton OaksPapers* 22 (1968), pp. 83, 85, esp. 90 and 91. Ch. Bouras shares the same opinion ("Master Craftsmen, Craftsmen and Building Activities in Byzantium," *The Economic History of Byzantium from the Seventh through the Fifteenth Century*, ed. A. Laiou (Washingtion D. C., 2002), p. 547). As opposed to the Byzantine period, for which available data on the manner of transferring painter's models is scarce, there are far more numerous sources explaining this problem in the post-Byzantine period. Cf. K. Ph. Kalafatis, "Sketchbooks and Sketches in the Postbyzantine Period," *Zbornik Matice Srpske za likovne umetnosti* 32-33 (2003), pp. 143-149 (with an elaborate overview of literature on the subject).

14    *Ktetor's* scenes with the representation of architecture, besides mosaic and wall-painting, were also done as illuminations, on seals and in relief. It is obvious that due to differences in media and technique, as well as the size of the *ktetor's* scene, it is difficult to make comparisons between certain artistic solutions.

15    Charters were written on the walls of the churches in Studenica, Žiča and Gračanica monasteries in Serbia and in Adreaš monastery in Macedonia. More about the legal significance of the portrait on charters in: V. Đurić, "Portreti na poveljama vizantijskih i srpskih vladara" (Portraits on Charters of Byzantine and Serbian rulers), *Zbornik Filozof-*

planation why the founder was always depicted only with the building that he had erected, while the buildings or parts of them to which he had no founder's right were completely left out of the representation of the architecture.

Accordingly, the manner of depicting the founder's architecture *a priori* had to comply with two obligations: The first typological obligation of the painted architecture in the hand of the founder was that even at a first glimpse the depicted edifice unmistakably looked Christian. Therefore, architectural elements that were common to all illustrations of churches – the semi-circular apse on one side, the entrance portal opposite, the dome or roof with a cross on top of it – were always used. Regardless of the shape, the time or place where it was produced, every picture of a church had to have these elements. They were always shown and often they were emphasized for symbolic reasons. Therefore, these elements of painted architecture could be called the *topoi* of a Christian building. The second, equally important aspect of the representation of the church in the founder's portrait was that the depicted building had to be represented as authentically as possible to illustrate its specific features in the greatest measure, seeing that only the actual building was the founder's gift. Thus, a different, substantial role of the founder's architecture was fulfilled, the principal aim of which was to illustrate the features of the endowed church as accurately as possible.[16]

---

*skog fakulteta, spomenica Viktora Novaka* 7/1 (1963), pp. 251-269, and G. Babić, "O portretima u Ramaći i jednom vidu investiture vladara" (About portraits in Ramaća and one particular representation of investiture), *Zbornik za likovne umetnosti* 15 (1979), p. 173. Henri Franses also believes that the portraits of founders had a legal role. Cf. Franses, op.cit., p. 20.

16  A. Stojaković demonstrated that ktetorial architecture never represented the framework or background for another scene, but was "subordinate to the expression of the basic idea – explaining the shape of its model". Cf. A. Stojaković, "Ktitorski model Resave" (The *ktetor's* model of Resava), *Moravska škola i njeno doba* (L'école de la Morava et son temps), ed. V .J .Đurić (Belgrade, 1974), pp. 269-274; eadem, *Arhitekstonski prostor u slikarstvu srednjovekovne Srbije* (Architectural Space in Serbian Medieval Painting) (Novi Sad, 1970), p. 77. Seeing that the case of the *ktetor's* portrait with a church also involved a kind of legal document, an interesting analogy can be established with the language of the *ktetor's* charter. Namely, in *ktetors'* charters, one encounters the phenomenon of *diglossia* – certain typified parts of the charter (the invocation, *arenga*) were written in literary language and with the established literary expressions, while the parts of the charter mentioning the gifts to the monastery were written in the popular language. Accordingly, there are some *topoi* for depicting the architecture in the narrative scenes, and a certain realism in the visual language, precisely expressing the appearance of the particular endowment in the representation of the *ktetor's* architecture. I focus on this topic in my text "Monastic founder holding a church as a fine art representation of the

The question arises as to what is the basis for painting this important part of the iconographic program? There is no record in any well-known painter's manual – *hermeneia*[17]– of the position where the founder's portrait was to be painted, nor about the manner of representation of the architecture in his hands. Certainly, no ready-made models – cartons – which, as some authors suggest, were sometimes used for copying certain figurative and, in particular, decorative motives, could have existed for the founder's portrait with architecture as the specific reflection of an actual architectural work.[18] In connection with painting the representation of the founder's portrait with architecture, the only thing we know reliably is that it was mandatory, because it represented the most important segment of the ritual founder's right.[19] If one agrees with the assumption that the founder's architecture was a sort of visual transposition of a legal document into a picture, then the way in which it was being painted had to rely on facts, that is to say, on the existing building.

Therefore, the painter entrusted with depicting the founder's portrait, due to the complexity of the task of painting according to a "live model", certainly must have been the best artist in the guild.[20] One can hardly imagine that he painted the portrait separately from the representation of the church, or that the painting of the architecture was entrusted to someone else. Thus, we may assume that he had enough experience and skill to realistically depict the appear-

---

monastic founder law". Cf. Č. Marinković, op. cit., *Medieval Law in Serbian Lands in the Mirror of Historical Sources*, ed. S. Ćirković (Belgrade, 2009), pp. 321-335.

17  A. N. Didron, *Manuel d'iconographie chrétienne grecque et latine, traduit du manuscript byzantin la guide de la peinture par le Dr. Paul Durand* (Paris, 1848; reprint: New York, 1963); P. Hetherington (ed.), *The "Painter's Manual" of Dyonisius of Fourna* (London, 1985); A. Skovran, "Uvod u istoriju slikarskih priručnika" (Introduction to the History of Painting Manuals), *Zbornik zastite spomenika culture* 9 (1958), pp. 40-47; N. Brkić, *Tehnologija slikarstva, vajarstva i ikonografija* (The Technology of Painting, Sculpture and Iconography) (Belgrade, 1991), pp. 153-292; none of the four painting manuals presented by M. Medić – in the original or in translation – contains any mention of the manner or position of the *ktetor's* portrait. Cf. M. Medić, *Stari slikarski priručnici* (Old Painter's Manuals) I-II (Belgrade, 1999).

18  Sl. Nenadović, *Građevinska tehnika u srednjovekovnoj Srbiji* (Building Techniques in Medieval Serbia) (Belgrade, 2003), pp. 48-49, believes that such cartons existed. However, there are also quite opposite views. Cf. Scheller, op. cit., p. 57, f. 164; Winfield, op. cit., pp. 63-139.

19  Č. Marinković, *Slika podignute crkve* (Image of the Completed Church) (Belgrade, 2007), pp. 10-12.

20  In medieval times, it took at least seven years to learn the craft of painting. Cf. Sv. Radojčić, "Zographs," p. 13; eadem, "Kraljeva crlva u Studenici" (The King's Church in Studenica), *Osam vekova Studenice* (Belgrade 1986), pp. 207-214.

ance of the existing church. Usually, the church was painted only after the fina-
lization of the construction work, and often started from the dome and the apse
at the east end and proceeded westwards. Following this order, the representa-
tion of the founder's portrait with a church, at least in Serbian medieval art, was
one of the last images depicted in the sequence of the compositional scheme,
most often in the first zone of the bay in the nave or the narthex.[21] Even when
the church was painted immediately after the architectural works were complet-
ed (which was rarely the case), this scheme would make it possible for the artist
to depict the church in the hands of the founder, according to the structure that
had already been built. Since one can establish the angle from which the majori-
ty of churches were observed before they were painted, it is safe to assume that
the architectural representations in the hands of the founders were done on the
basis of the completed building.

1. The *ktetor* is always depicted only with the building he himself had built,
while constructions or segments of architecture over which he had no *ktetor's*
rights were totally omitted in the given depiction of architecture. This is particu-
larly obvious in the examples where, as with chapels within larger architectural
complexes, it was necessary to selectively represent only the building the given
*ktetor* had constructed as his endowment. In the course of our research we noted
several such examples. Most numerous are the ones from the art of early Chris-
tianity, where the chapels were more often placed adjacent to larger architectural
complexes.[22] Thus, Serbian medieval art represents King Radoslav's legacy, the
exonarthex of the Theotokos Evergetis church in Studenica, as well as all the
three legacies of Archbishop Danilo II in the Patriarchate of Peć – the Holy Vir-
gin Hodegetria church, that of St. Nikola and the exonarthex.

2. The representation of architecture in the *ktetor's* hands always depicts the
outer appearance of the building. The way the exterior of the *ktetor's* architec-

---

21   In Serbian medieval art, especially that of the 13th century, the place of the ktetorial por-
     trait with the church is linked to the donor's tomb and is always on the southern wall of
     the nave as in Studenica, Mileševa, Sopoćani and Gradac. In the 14th century, there was
     a clear separation of the donor composition from the tomb location, except for the first
     donor composition in Dečani. In the last quarter of the 14th and in the 15th century, in
     Serbian art one can find donors' compositions on the western wall of the nave (Ravanica,
     Resava/Manasija). In the case of Byzantine art one cannot conclude that there was a strict
     rule about the place of the donor composition.
22   Rome, baptistery of the Basilica of St. John Lateran, chapel of St. Venantius, St. Maria
     Antiqua, chapel of SS. Quiricus and Julitta, Old Basilica of St. Peter, chapel of Pope
     John VII.

ture was represented was not arbitrary and depended on a number of interconnected elements. It is always presented from a certain angle, using one of the three projections (frontal and profile orthogonal projection, frontal inclined projection, or with all three sides of the building simultaneously represented). In Serbian medieval monumental art, the church in the *ktetor's* hand was, as a rule, painted from one of its lateral sides – the northern or the southern. The frontal depiction of the western façade is rare, since it was then impossible to depict the apse which is, besides the cross, the most important element of any Christian building. The simultaneous representation of the frontal look of a building was very popular in the art of Antiquity, and was therefore in most cases omitted in representations of early Christian architecture – in order to avoid possible confusion. Later on, the medieval artists preferred the simultaneous representation of at least two sides of the building, thus rendering a more realistic representation of the structure, especially in the case of the *ktetor's* architecture.

3. Regardless of the angle of representation and the utilization of various projections, the general appearance of the building was always correct. The church is always depicted from the point where all its morphological elements are visible, especially its upper construction. Thus, the basic contour of the building is accurately rendered, no matter whether it is a basilica, single- or multiple-domed, longitudinal, central or of any other shape. We arrive at such a conclusion primarily by comparing the same representations within one church,[23] as well as by comparing the depicted constructions with the real architecture. Further evidence for this claim lies in the churches that have no definite external shape, as is the case with cave churches.[24]

4. As for the depiction angle of the *ktetor's* architecture, a very interesting and, until now, little noticed or explained characteristic appears – *parallelism.*[25] This term describes the interrelation of the depicted and the real architecture, i.e. the relation between the place where the *ktetor's* portrait is situated within the archi-

---

23   Ktetorial architecture is twice represented in Mileševa, Donja Kamenica, Dečani, i.e. Oskhi, Kastoria (Ag. Anargiroi), Chios (Panaghia Krena) and Boïana.

24   This is especially obvious in the example of the cave church in Vardzia (Georgia). Although it initially seems that Queen Tamar holds an abstract object in her hand, a black square, without any reference to the real building, through careful analysis of the visible facade, its shapes and external proportions one can reach the conclusion that this was the external appearance of the real building. Cf. Č. Marinković, *Image*, p. 110, ill. 53, 54.

25   The term parallelism is used here in its wider sense and has the meaning of the geometrical concept of parallel planes.

tecture and the view-point of the depicted church.[26] The represented architecture extends parallel to the real building and, when observing the painted church, all the main elements point in a direction so as not to confuse the beholder. Therefore, if the painted representation is from the southern side of the church, its appearance on the *ktetor's* portrait is represented from the northern side, and vice versa. Thus, the painted apse is directed towards the altar, the painted portal towards the western façade, and the painted and the real façade extend in a parallel fashion, which in such a representation ensures the correct orientation.

It is unusually interesting that, despite the great chronological, stylistic and geographical span in which Serbian medieval art came into being, and despite the numerous iconographical changes and traits of individual monuments, the relation of depicted and real architecture remains constant and demonstrates an astonishing consistence. If the depicted endowment is situated within the *ktetor's* graveside portrait at the southern side of the nave, as is characteristic of 13th century art, the painted church reveals its northern façade.[27] If, for some particular iconographical reason, the *ktetor's* portrait with the church is situated on the northern side of the church, its opposite, southern side is depicted on the painting.[28]

A possible explanation for the meaning of the afore described characteristic of parallelism could be the equalization of the semi-space of the painter, who is looking at the building to be painted, and the observer, who is looking at the depicted building in the *ktetor's* hands, i.e. the painted and real spaces are thus equated.[29] Therefore, this characteristic, indirectly, could be one of the most powerful arguments in favor of the presented assumption that the ktetorial architecture was created on the basis of an already finished building.

Due to the vastly heterogeneous material collected, as well as due to the non-existence of the precise spot where the *ktetor* is depicted with the church in Byzantine art, parallelism – as a characteristic of the depiction of ktetorial architecture in Byzantine art – is for the time being impossible to outline with certain-

---

26    This term was first used by A. Stojaković ("The *ktetor's* Model of Morača," *Starinar N. S.* 15/16 [1966] p. 95-109).

27    The northern façade is represented in the nave of Mileševa, Studenica, (southern chapel of the exonarthex), Sopoćani, Gradac, Arilje, Psača and Ohrid, (SS. Constantine and Helen).

28    Mileševa, narthex, Dečani (south side of the NE pillar of the nave) and Treskavac.

29    According to the rules of central projection and perspective, the space is divided into two semi-spaces: the one in front of the observer, that can be seen, and the one behind him, that can be observed only with the use of a mirror.

ty.[30] Some examples of monumental painting demonstrating this characteristic are not sufficient for producing a reliable general conclusion.[31] However, this feature is present with all the characteristic examples of ktetorial architecture, e.g. in Vardzia, Boïana and Chora.

## III.  Principles of Schematization

Since medieval art is anti-illusionist in its character, there are certain principles of architectural representation that one must be familiar with in order to establish, as precisely as possible, what the real similarity is between the erected church and its image in the hands of the *ktetor*. The subject matter elaborated here from Serbian medieval and Byzantine art is chronologically, territorially and culturally extremely heterogeneous, and it is very difficult to establish rules in it that could apply to all the monuments. However, the ktetorial representation of architecture is subject to some basic principles of schematization that, to some extent, are valid for the representation of medieval architecture in general. Based on the material published in my book, the following general features prevail in the architectural representation in *ktetors'* compositions:

---

30  Valuable confirmation of the assumption offered here, stating that the place of painting the *ktetor's* portrait with the church and the angle at which it is depicted are in a very precise correlation, are those representations that are not in direct relation with monumental painting, like representations of ktetorial architecture in miniatures. Regretfully, they have not been preserved in large numbers. There are only two such examples of our material – Turin's Typicon and the Oxford Lincoln College Typicon. In these two examples, the churches depicted in the hands of the *ktetors* are presented from the southern and the northern side respectively, so it is impossible to observe some sort of regularity. Also, the first miniature was destroyed in the fire in Turin's Library in 1904, and testimony of its existence is only in recorded drawings. Luckily, the Typicon of the Oxford Lincoln College did not experience such a fate and is preserved in the Oxford Bodleian Library. The difficulty in reaching any sort of conclusion on the documentary value of these miniatures lies in the fact that neither of the two churches presented in these Typica – the Thessalian Monastery of Nea Petra and the Constantinopolitan Monastery of the Virgin of the True Faith  (Theotokos tis Veveias Elpidos) have been preserved. We know about them only from the very meager historical sources, which in fact prevents any sort of verification based on the comparison of the real and painted architecture, and the assumptions presented and referred to here.

31  Cf. Č. Marinković, *Image*, pp. 60-62.

## 1. Eliminatio angoli[32]

Projections used for the representation of *ktetor's* architecture in Byzantine and Serbian medieval art until the mid-13th century were combinations of profile and frontal orthogonal projections. Their application enabled the simultaneous representation of two sides of the building by *eliminating angles (eliminatio angoli)* and representing architectural masses in the same projection plane. Thus, the simultaneous representation of adjacent façades was obtained that cannot otherwise be seen at the same time[33] – the volume of the represented object is annulled, just as the illusionism from the times of Antiquity is ruled out in presenting space.[34] This is one of the stereotypes that would remain very popular throughout the whole of the Middle Ages, and it was especially pronounced in early Christian art – first on sarcophagi and later in monumental painting. In accordance with this dominant principle of the representation of architecture, the frontal representation of the building in the *ktetor's* hand was very rare.[35]

However, from the beginning of the 14th century, the frontal and profile orthogonal projection were suddenly being replaced by the more frequent, frontal inclined projection. The introduction of the frontal inclined projection as the manner of presenting architecture, especially ktetorial architecture, produced buildings of larger volume that were, at the same time, more realistic and thus, in a certain way, satisfying the condition of the objective representation of shape. It rendered the painted representation of a church closer to the appearance

---

32  The use of Latin terms for the schematization principles is in accordance with the way this problem was treated by W. Ueberwasser. Cf. W. Ueberwasser, "Deutsche Architekturdarstellungen um das Jahr 1000," *Festschrift für Hans Jantzen* (Berlin, 1951), pp. 47, 49, esp. 54.

33  This is the case with the architectural representation in the churches of St. Michael in Ston, Mileševa, King Dragutin's Chapel in Đurđevi Stupovi, the Church of St. Peter in Bijelo Polje, Kučevište, Dobrun, Pološko and Ravanica, and also in Panaghia Phorbiothissa and Dali Church in Cyprus, Agioi Anargiroi in Kastoria, the Holy Saviour in Nerediza and Ivanovo (a destroyed church).

34  Plotinus' teachings provided the theoretical justification: Wishing to obtain maximal visibility in the painting, at the same time the realization of Nous – which, according to Plotinus, is the basic task of art – all the painting's elements are brought to the front plane. This provides the reality of issues, connected by the logic of art and not by the imitation of the outside world. A. Grabar, "Plotin et les origines de l'esthétique médiévale" (see fn. 5).

35  This fact can be explained by the great popularity of frontal representations of ancient cult buildings in the art of Antiquity, most frequently on Roman coins. Cf B. Pick, "Die tempeltragenden Gottheiten und die Darstellung der Neokorie auf den Münzen," *Jahreshefte des Österreichisches Archäologischen Instituts* 7 (1904), figs. 19, 21, 22, 23, 29, 30, 35, 38, 39, 41.

of a real building. This aspect makes examples of ktetorial architecture that can be related in style and chronology interesting.[36]

## 2. Augmentatio

One of the very important and widely applied principles of presenting Christian buildings is *enlargement (augmentatio)* of some parts of the architecture, according to their symbolic significance. This principle was mainly used when representing entrance portals.[37] They were depicted enlarged and mostly covered the whole of the façade. Symbolically, the portal represents the border between the two worlds – the profane and the divine – pagan and Christian. By its mere size, the portal thus represented invited believers into the temple. In the early Christian period, a curtain was often painted over it.[38] The principle of *augmentatio* was used in the representation of apses too.[39] Morphologically, the apse is

36    This applies to painted representations of architecture in King Milutin's foundations: the King's Church in Studenica, Staro Nagoričino and Gračanica, in which such a projection is found as a pronounced stylistic characteristic. The frontal inclined projection prevails here, stressing the volume of the building and producing a three-dimensional effect that contributes to the more realistic painting of the building.

37    The enlarged portal without a clearly defined door is represented in: Studenica, the southern chapel of the exonarthex of the Catholicon, Mileševa, nave and narthex, King Dragutin's Chapel in Đurđevi Stupovi, Bijelo Polje, Staničenje, Pološko, and in Parenzo, the Euphrasian Basilica, Rome, St. Agnes outside the walls, the Venantius Chapel at the Lateran Basilica, St. Cecilia in Trastevere, St. Marco, Phocis (Hosios Loukas), Monreale Cathedral, Kastoria (Ag. Anargiroi and Ag. Nikolaos tou Kasnitzi), Nerediza, Boïana (church and the chapel on the upper floor), Belisirma Kirk Dam Alti Kilise, Cyprus (Dali), Bačkovo and Karlukovo.

38    The reason for representing a curtain in the iconography of early Christian art is relatively simple: morphologically, ancient temples' and Christian basilicas' fronts do not differ much. The curtain indicates the divinity of the space, since it represents the focus of Jewish religious practice, too. At the same time the curtain replaces the cult statue that is usually situated in that very place in pagan temples. Thus, the possible confusion between a temple in the times of Antiquity and a Christian church is avoided. Cf. D. Amit, "The Curtain Would Be Removed for Them (Yoma 54a): Ancient Synagogue depictions," *From Dura to Sepphoris: Studies in Jewish Art and Society in Late Antiquity*, eds. L. I. Levine and Z. Weiss (Rhode Island, 2000), pp. 231-236.

39    In Serbian medieval art, enlarged apses are represented in: Mileševa (nave and narthex), Sopoćani, King Dragutin's Chapel in Đurđevi Stupovi, Arilje, the Patriarchate of Peć (Holy Virgin Hodegetria), Dečani (south side of the NE pillar of the nave), Mateič, and Ramaća, and in Byzantine art in: Parenzo (Euphrasian Basilica), Rome, St. Agnes Outside the Walls, the Venantius Chapel at the Lateran Basilica, St. Cecilia in Trastevere, St. Marco, Phocis (Hosios Loukas),  the Monreale Cathedral, Kastoria (Ag. Anargiroi and

the part of a church that does not exist in the ancient, pagan temple and there-fore, in a certain way, its very existence can symbolize a Christian building.[40]

## 3. Reductio numeri

The third, very widespread principle of architectural schematization is the *re-duction of the number (reductio numeri)* of the identical architectural or decora-tive elements for the purpose of a clearer representation of the whole. The ele-ments reduced in number are usually the windows on the high drum of the dome or on the façade, small arcades, blind arches and niches. This principle is partic-ularly applied in representing windows – there are often fewer than the actual number.[41] However, this number reduction rule did not have strict regulations, except that the number of represented elements never exceeded the number of elements visible from one view-point.[42]

## 4. Reductio formae

The fourth principle of schematization is the *alteration of shape* of certain archi-tectural elements *(reductio formae)* that are precisely located on the façade. This is most often the case with the shape of windows that were depicted as rectangu-lar, with arc-like endings,[43] but also with niches depicted in the same way as windows.[44]

---

Ag. Nikolaos tou Kasnitzi), Nerediza, Boïana (church and the chapel on the upper floor), Belisirma Kirk Dam Alti Kilise, Cyprus (Dali), Bačkovo, Volotovo and Karlukovo.

40   The apse is the most important part of a Christian cult building, within which the Chris-tian mystery of the transformation of bread and wine into Christ's body and blood takes place in the presence of a bishop as Christ's representative on earth. Its semi-spherical shape symbolizes heaven that descended on earth. According to the explanation of Ger-manus the 1st (715-730), Patriarch of Constantinople, apses also represented the "cave in which Jesus was born and in which he was buried". Germanus I, Hist. Mystagogica, 2. Quoted after: C. Mango, *The Art of Byzantine Empire 312-1453* (Englewood Cliffs, 1972), pp. 142.

41   Examples are from the Euphrasian Basilica in Parenzo, the St. Lawrence and St. Agnes churches in Rome, Hagia Sophia in Constantinople, the Monreale Cathedral, as well as the Church of St. Nicholas in Psača.

42   Based on our material, one exception might be the example of three windows on the dome drum of the church in Dali in Cyprus.

43   Mileševa and Ramaća.

44   Mileševa, narthex.

## 5. Inversio

The fifth, most seldom used principle of schematization is the *relocation* of architectural elements by 180° in relation to their position on the real building *(inversio)*, however correctly presenting that element's shape.[45] This principle was also applied when depicting the windows.[46]

All the characteristics described here are the general principles of schematization of ktetorial architecture. In the quest for realistically transposed elements, these principles must be taken into account, like those the use of which does not change the final conclusion in terms of the realism of representation.

To conclude: based on the analysis of our material, one might conclude that certain architectural elements of ktetorial architecture were always depicted in the same or in a similar manner, independent of the real look of the building they represented. Those elements are: domes with an extended drum and *transennae* on the windows,[47] crosses, enlarged portals without clearly defined doors, and enlarged apses. Such elements were also often used when representing other kinds of painted architecture.[48] Therefore, they might form the corpus of commonly applied architectural elements that in fact could be termed as the *topoi* of painted ktetorial architecture. The use of only those elements in depicting ktetorial architecture did not contribute to the realism of representation and its credibility. If there was no inscription accompanying such a representation, or if it were to be removed from its original position, and based only on its appearance, one would not be able to establish what kind of architecture it represented: architectural décor[49], or a real building.

---

45  This principle is best illustrated by the depiction of a flying buttress on the main monastery church in Gradac. This flying buttress, the most characteristic element of the Gradac architecture, is represented in the *ktetor's* architecture on the western side of the north choir, by the narthex wall, instead of on the eastern side, with the apse, where it is actually situated.

46  In the Staničenje church, in the center of the north façade, an arc-finished window is depicted, while in fact the only window on that church is situated on the southern wall, at the level of the second figurative zone.

47  One can find such a representation in: Mileševa, (nave and narthex), Sopoćani, Arilje, Donja Kamenica, the Patriarchate of Peć (Holy Virgin Hodegetria), Dečani (south side of the NE pillar of the nave), Lesnovo, Mateič and Psača.

48  In the Sopoćani Monastery, on the northern wall of the southern chapel, in the scene "The Transfer of the Relics of St. Simeon from Chilandar to Studenica," the depicted church – "Studenica" – repeats the appearance of the Sopoćani church from the *ktetor's* composition.

49  T. Velmans, "Le rôle du décor architectural et la représentation de l'éspace dans la peinture des Paléologues," *Cahiers archéologiques* 14 (1964), pp. 183-216.

The number, shape and colour of the windows, their location on the façade, as well as the decorative façade elements generally depend on the look of the completed building. These elements are specific elements of the architectural representation of ktetorial architecture.

The colour of the façade, in some cases its texture as well, and certain characteristic details would be realistic elements that must have been created based on the observation of the completed building. According to the principle of synecdochical representation, in the consciousness of the medieval beholder they could have replaced the whole building. Based on the material at our disposal, the characteristic details would be: (presently walled-in) the arch between the proscomidia and northern choir in Sopoćani, the flying buttress in the church of the Gradac Monastery, the characteristic manner of construction, i.e. the façade in the Đurđevi Stupovi chapel and in the naos in Dečani, the wooden porch of the church in Donja Kamenica, the niches on the façade in Pološko and the rosette window in Manasija.[50]

## Conclusion

One could, therefore, divide the representations of ktetorial buildings into three basic categories:

1. Representations dominated by the precision of the representation of the church as a whole and in detail. This category is characteristic only of ktetorial architecture, and its realism could also be called "portrait-like".[51]

2. Represented buildings where one element, transposed from reality, conveys the idea of the structure. In keeping with the medieval understanding of the

---

50  Č. Marinković, *Image*, ills. 76, 79/80, 81, 90/91, 120/121, 141/142, 143/144, 175/176. About the rose window in Manasija cf. M. Mandić, *Rozeta na Resavi* (Rose Window on Resava Monastery) (Kruševac, 1986), pp. 17-52. During the archeological campaign in 2005, an archeologist from the Institute for the Protection of Cultural Heritage in Belgrade, Mr. Marin Brmbolić found large pieces of a rose window that typologically corresponds to the one depicted on the *ktetor's* composition. I would like to express my gratitude to him for the information he gave me.

51  Examples belonging to this group are: Sopoćani, Arilje, the King's Church in the Studenica Monastery, Staro Nagoričino, Gračanica, Peć, Ravanica and Manasija, i.e. Vardzia, Boïana, Chora, Donja Kamenica and the church in Ivanovo.

principle of the representation of architecture, they could also be regarded as realistic. We shall name them *evocative*.[52]

3. Buildings that, for some reason, are represented in a schematic way, with one or without any realistic elements, or those that do not have any specific feature of the real architecture at all. We shall name them *constructed*. Examples in this group are almost exclusively buildings without a defined external appearance.[53]

The churches on the ktetorial portraits are among the most beautiful and most realistic depictions of architecture in medieval painting. This seems natural, since they were done by the best artists, according to a "live model". And while the *ktetor's* portrait could also have been conveyed by means of the charter with a portrait, the depiction of the church always had to be done *in situ*, based on the already finished building. And the actual building, the real object of the *ktetor's* endowment – because of its legal consequences – had to be represented correctly. Undoubtedly, even in this most realistic kind of medieval painting, there were certain principles that modified the painting in terms of the real building. One must be familiar with them, while dealing with such representations, in order to establish, as accurately as possible, what the real similarity is between the completed church and its image in the hands of the *ktetor*.

---

52  Examples belonging to this group are Gradac, King Dragutin's Chapel in Đurdjevi Stupovi, Dečani (south side of the NE pillar of the nave), Pološko, Psača i.e. Hagia Sophia in Constantinople and the Monreale Cathedral.

53  The Venantius Chapel at the Lateran Basilica in Rome, the Chapel of St. Quiriqus and Julitta at the St. Maria Antiqua Church in Rome, and Chapel of Pope John VII at the Old Basilica of St. Peter in Rome, as well as the cave churches in Cappadocia (Belisirma Kirk dam alti kilise) and Udabno.

# The Character and Nature of Byzantine Influence in Serbia (from the End of the Eleventh to the End of the Thirteenth Century): Reality – Policy – Ideology

*Vlada Stanković*

Despite its defining influence on the development of the Serbian nation and state, the national ideology and the national being even in modern times, Serbian medieval history still represents quite an open field for research and study, with amazingly few established "facts" and unshakable opinions. The formative period of the Serbian medieval state, ranging from the end of the eleventh century to the time when Stephen Nemanja became a grand zhupan around 1166, is particularly problematical. Moreover, the uncertainty of our knowledge spreads also to the period of the strengthening, rise and flourishing of the Serbian medieval state, which is usually identified with the rule of the Nemanjić dynasty, the descendants of Stephen Nemanja, lasting until 1371. Accepted opinions, sometimes based on nothing more than assumptions – regardless of the importance or credibility of the scholars who had articulated them – have too often and too easily been presented as established facts and repeated time and again in various articles, books, handbooks and studies through the generations of scholars.

Some examples of that procedure will be referred to in the relevant places in the course of this paper, but I believe it is very important to stress from the outset the caution with which the studied topic should be approached, bearing in mind the scarcity of the written sources and, even in a greater measure, of the archaeological evidence and findings. Caution is also indispensable when articulating definite conclusions regarding the events, processes, personalities of Serbian medieval history and their interrelations. Similarly, the Byzantine influence on the formation and development of the Serbian medieval state, its ideology, culture, religion, letters and attitudes has not been studied, presented and understood adequately and correctly. The main objective of this paper will be, therefore, to present the various aspects of the Byzantine Empire's influence in medieval Serbia, and to try and formulate the framework in which this plethora of different questions should be studied.

The remarks that follow, concerning the topic of this paper, its title and the stress laid on the *character* and the *nature* of the Byzantine influence in Serbia, are closely connected with the previous introductory point, and bear similar methodological and bibliographical problems. The prevailing approach to studying Serbian medieval history is still the one I shall provisionally call the "na-

tional" approach. It means that scholars study Serbian history throughout the Middle Ages, from the Slavic / Serbian settlements on the Byzantine territories in the Balkans in the seventh century to the times of the destruction of the Serbian medieval state by the Ottoman Turks in the fifteenth century, concentrating mostly, if not exclusively, on the developments within "national borders", regardless of the different ways those borders could be formulated or comprehended. This is – fortunately, or unfortunately – not a singularity of Serbian historiography, but a widespread approach, which, undoubtedly, hinders the correct understanding of the historical processes, especially those which occurred when the notion of nation was different form the modern, 19th-century concept of nations, national states and respective ideologies. It is an approach which isolates Serbian history, or any other "national" history for that matter, from the contemporary and related historical events, and consequently, from the broader historical surroundings. It also means that some isolated and unconnected events from the sphere of so called 'national' history are brought together and studied as a unity, and that the Byzantine influence on medieval Serbia is clearly separated from its internal development. The consequence of this approach is that the broader historical context in which the events, their protagonists, and historical processes should be placed is not taken into account, at least not in the degree needed for an adequate analysis.

With this approach as its main tenet, the inconclusiveness and the pervasive lack of broader views on the development of the Serbian medieval state have remained the hallmarks of Serbian contemporary historiography, together with a reluctance to accept new methodologies, which would in their turn inevitably provoke new questions and challenge the century-old viewpoints from which the problems are being analyzed.[1] The tendency to rely more on secondary bibliography than to explore over and again from the beginning all the available sources – and especially the still not quite sufficiently studied Serbian sources – has contributed to narrowing the research horizon and to avoiding both in-depth case studies that would explore a problem or a source to its full extent, and syntheses that should offer more general, but at the same time more contextualized

---

1    Exceptions, commendable as they are, are very rare, and the most important will be referred to later in the text. Bearing in mind all the attempts, theoretical and practical, of modern Byzantine Studies in the last few decades to develop more quickly and to change its sometimes also century-old views and methodology in order to surpass the limits which hindered its progress for far too long (especially in comparison with studies of the medieval West), a similar process of reassessment, sadly, has yet to begin in the area of studies of the Serbian Middle Ages.

views of the problems that trouble our knowledge of Serbian medieval history.[2] The isolationistic methodological approach which placed the Serbian medieval state as a detached subject in the center of scholarly narrative, despite our hazy knowledge about the structure, borders, organization and the nature of the Serbian medieval state or states, created a barrier for a more complex analysis of Serbian medieval history in its correct geopolitical context and its natural historical surroundings in the studied centuries. The recognizable elements from the Byzantine Empire, Hungarian Kingdom, Constantinopolitan or Roman Church, western countries etc., are taken at whim and applied to the *case of Serbia*, in order to explain often very contradictory elements and processes that characterized the creation and development of the Serbian state-like organizations[3] from the tenth century onward.

By leaving the broader historical context out of their examination, scholars, consciously or not, have staunchly adhered to the 19th and early 20th-century historical thought and the idea of the 'national states', on the assumption that *national* history represents something like a separate historical development that is divided along national lines, and which can be studied and understood without taking into serious consideration the broader historical context. In one sense, the *commonplaces* – the *topoi* – thus became an integrated part of modern Serbian historiography, in the same sense as they represent a common feature of the old Byzantine and consequently Serbian medieval literature. The important difference is, nevertheless, that the *topoi* in modern historiography are usually not

---

2    The cornerstone of Serbian medieval historiography remains even today the imposing two-volume book by Konstantin Jireček, *Geschichte der Serben* (Gotha, 1911), (translated already in 1912, as *Istorija Srba*; an emended second edition appeared in 1952). This really impressive work by an erudite whose knowledge spread over the epochs influenced the following generations of Serbian scholars who rarely dared to doubt his conclusions or contradict his judgments. The authority of Jireček's *History* had as a peculiar side effect a self-imposed constraint in researching the sources by the generations that scientifically grew under the shadow of his book, which was their primary handbook on Serbian medieval history. To put it bluntly: the reliance on Jireček was so strong and the impression was created that if something – some historical source – is not referred to in his handbook, then in all probability there never was one of any significance, so that there is no need to go back to the sources, to reexamine them and search through them for new evidence. This unacceptable attitude, which runs through the subsequent Serbian historiography, significantly confined the research scope of the following generations of scholars of medieval Serbia, and equally important for the subject of this paper, strongly influenced their judgments on the value of the Byzantine sources for the historical development of the Serbian medieval state.

3    Which, without doubt, is a more correct way to name these entities than to refer to them as states, which would imply a much more complex and developed internal organization.

recognized as such and that they seem to gain validity with every subsequent repetition.[4]

For all the reasons stated above, it should come as no surprise that one of the best, relatively recent studies of the problems of Serbian medieval history comes from a non-Serbian, albeit Slavic scholar, Dimitri Obolensky, who has painted a vivid and intriguing picture of one of the most important personalities of Serbian medieval history, Stefan Nemanja's youngest son St Sava, and of Serbia in the last decades of the twelfth century and the first third of the thirteenth century.[5] In his *Six Byzantine Portraits* (published in English in 1988) he offered a comprehensive and well-researched insight into the complex nature of Serbian history in these turbulent decades and analyzed the related historiography. Therefore, it is all the more surprising that his analytic attitudes and serious approach left such little trace on subsequent Serbian scholarly production, in spite of the Serbian translation that followed only three years after the book's original publication in English. On the other hand, even Obolensky's account of Serbian historical development and his depiction of the *political* background that engendered the gigantic figure of St Sava remain, in spite of all his in-depth analysis, essentially rooted in the traditionalistic approach that separates nations and their histories, thus leaving the broader, especially Byzantine context only as the background, where it serves as an important but still not predominant part of the *decor* of the historical *stage* of Nemanja's and Sava's Serbia in the twelfth and thirteenth century.[6]

---

4   For example, the voluminous book by B. Bojović, *L'idéologie monarchique dans les hagio-biographies dynastiques du Moyen âge serbe,* Orientalia christiana analecta 248 (Rome, 1995), in spite of its more than 700 pages of text, is unfortunately almost completely useless, precisely because of the reasons specified above. It represents a compilation of the established opinions repeated and echoed for decades, with a complete ignorance of the characteristics of each period which it aspires to cover (from the "origins" until the 16th century). For the sake of truthfulness and clarity it should be said that Byzantium, Byzantine history and especially Byzantine sources essentially do not exist in this treaty on the ruler's ideology in the Serbian medieval texts!

5   D. Obolensky, *Six Byzantine Portraits* (Oxford, 1988). Serbian translation: *Šest vizantijskih portreta* (Belgrade, 1991), chapter 4.

6   The language barrier which hinders the "internationalization" of Serbian Medieval Studies, should not, nevertheless, be understood and (mis)used as an excuse to the western and other Slavic medievalists for their huge, almost total ignorance of Serbian medieval history and modern historiography. The evident lack of interest in the West and in the East for Serbian history contributed to the awkward position of the contemporary Serbian historiography as a purely 'national' discipline. Without attempting to distribute the blame for the unsatisfactory state of scholarship on the Serbian Middle Ages, it should be self-evident that the two processes are interrelated, and that the rise of interest for recent

In what follows, I will try to place and define as accurately as possible the broader historical context in which Byzantine – Serbian relations were developing from the end of the eleventh to the end of the thirteenth century and to discern the quality of these mutual relations during that period. To return to the point stated above, I do not wish to oppose to the aforementioned 'national' approach a 'Byzantine' one, but I will insist on the Byzantine perspective in studying relations between Serbia and Byzantium and the latter's influence on the development of the Serbian medieval state. This does not in any way mean that the Byzantine models should be simply transferred to Serbia and applied there with some small modifications, a practice sometimes used, and rightly criticized. My appeal for the contextualization of historical events, processes and relations, and therefore for placing the development of the Serbian medieval state in the accurate historical context, implies that the history of the birth of the Serbian medieval state of the Nemanjić should be studied bearing in mind the contemporary events in Byzantium,[7] as well as the development and the changes the Byzantine Empire itself underwent from the end of the eleventh century until the fall of Constantinople in 1204 and afterwards. Without a broader view on the one hand, and more detailed and specified analyses of the various problems on the other, I am skeptical that we can advance and open new ways for both detailed research and broader syntheses. The terms *character* and *nature* used in the title of this paper represent, therefore, in the first place an insistence on the necessity to view Serbian medieval history as part of a broader historical context, represented by the Byzantine Empire with its sphere of influence, even if this means that

---

Serbian historiographical works should contribute to their better quality and vice versa. The mediocre works by John V. A. Fine remained for decades the only "authoritative" studies of Balkan medieval history in English (*The Early Medieval Balkans: A Critical Survey from the Sixth to the Late Twelfth Century* [Ann Arbor, 1983]; *The Late Medieval Balkans: A Critical Survey from the Late Twelfth Century to the Ottoman Conquest* [Ann Arbor, 1987]) until the recent overview by F. Curta, *Southeastern Europe in the Middle Ages 500-1250* (Cambridge, 2006), whose subject is too broad and whose narrative is overloaded with facts and political figures. Jadran Ferluga's collection of studies (*Byzantium on the Balkans. Studies on the Byzantine Administration and the Southern Slavs from the VIIth to the XIIth Centuries* [Amsterdam, 1976]) is still very useful for specific problems.

7    One should also take into account, of course, the events and developments in other neighbouring countries, especially Hungary and Bulgaria. Nevertheless, the main focus in the present study should inevitable be the *Byzantine* aspect of the medieval history of Serbia, which was in any case the strongest and the most dominant one, since many of the members of the Nemanjić dynasty modeled themselves and their policies according to Byzantine models.

in pursuing that research path more questions will have to be posed than answered.

For evident reasons, it would be impossible to analyze in detail the Byzantine influence in Serbia and the quality of their mutual relations in just one paper – in other words, to present the development and history of the Serbian state through more than two centuries. The focus of this paper will, therefore, be laid on a different methodological approach and on a new assessment of some of the most important periods, personalities, events and problems from the eleventh until the end of the thirteenth century, in an attempt also to offer some general conclusions about the Empire's policy and influence in Serbia:

- Eleventh-century context: Constantinople's new strength
- Twelfth-century context: Stephen Nemanja, the founder of the dynasty, and his connections and dealings with the Byzantine Empire;
- Thirteenth-century context: King Uroš I and his relations with the "Byzantine world" before and after 1261.

## I.　　Eleventh-Century Context: Constantinople's New Strength

The eleventh century, which started with the Byzantine Empire's amazing *reconquista* of the vast territories in the Balkans and their inclusion within the Empire's borders, signified a qualitatively completely different political and cultural environment, compared with the previous centuries. Byzantine attitudes, the Empire's presence, the level of its influence and the significance of the interrelations with the Balkan Slavic states, with the Bulgarians and the Serbs in the first place, changed essentially, once Byzantium overwhelmed the rivaling Bulgarian state and brought back its military, its administration and everything that accompanied them to the old frontier line of the Sava and the Danube.

The vast possibilities which *direct* control of these enormous territories offered to imperial power, ambitious clerics but also to the rich and well-off aristocrats, who now had a chance to acquire and enjoy in safety their possessions at the former frontier or in regions which were earlier to some extent necessarily exposed to attacks from the north, changed the ways in which the Balkans were comprehended in Constantinople and in the Byzantine Empire in general. At the same time, the new situation changed the amount of 'investments' in the capital's broadly understood hinterland, in the meantime changing the need and also the willingness of the central government to build secular and monastic foundations in this area, especially along the most important communication routes –

the case of Skopje, the newly promoted center of the vast theme of Bulgaria is an instructive example.[8]

The other factor that helped significantly in spreading Constantinople's direct influence in the Balkans was the Archbishopric of Ohrid, which encompassed under its authority the vast territories from the Danube in the north to Ohrid and further down in the south. Directly appointed by the emperor, the Archbishop of Ohrid had control over the web of bishoprics that served as powerful tools of influence on and control of the local Byzantine governors, and maybe more significantly, of the local, native rulers and their "barbarian" population.

The importance which the conquest of the Balkans had for both sides should not be underestimated: the awareness of Byzantium's undisputable dominance, the strong belief in the power of the Empire and the sense of security that per-

---

8    The fact that, immediately after Skopje, one of Samuel's strongholds, had become the center of the newly founded vast theme of Bulgaria, the town and its environs started to receive imperial attention can hardly be seen as a mere coincidence. Immediately after its "liberation" from the Bulgarians, imperial monastic foundations were built in Skopje's neighborhood, and the city was perceived as one of the "co-capitals" of the Empire, and therefore as the main goal of all the rebellious movements in the eleventh century. It is significant that not a single Byzantine source mentions the quite intense imperial activity around Skopje, see the charter of king Milutin from 1299/1300, S. Novaković, *Zakonski spomenici srpskih država srednjeg veka* (Belgrade, 1912), XV.1, pp. 608-621, especially p. 608. I, 612. XXV-XXVI, 613. XXXII; (new edition with a commentary in: V. Mošin, S. Ćirković, D. Sindik [eds.], *Zbornik srednjovekovnih ćiriličkih povekja i pisama Srbije, Bosne i Dubrivnika* (Belgrade, 2011), no. 92, pp. 317-329), and R. Grujić, "Vlastelinstvo Svetog Djordja kod Skoplja od XI do XV veka," *Glasnik Skopskog Naučnog Društva* 1 (1926), p. 46 sq. It is also very interesting that, as it seems, the head of St George was kept in Skopje (at least until the beginning of the 12th century) and that St George became a sort of patron saint of the now Byzantine Skopje, which is evident in the dedications of the new imperial complexes around Skopje (I thank my colleagues Ivan Stevović and Branislav Cvetković for fruitful discussions and information on this and many other related subjects). Since the mention of the theme of Bulgaria is not found after the rebellion of George [!] Vojtech in 1073, it seems very plausible that the weight of 'governing' the Balkan inlands was towards the end of the eleventh century transferred to the duces of Dyrrachion, who became undoubtedly the most powerful functionaries and provincial governors in the Empire in the second part of the eleventh century. A new, complete study of Byzantine Dyracchion, its role and importance in the eleventh century, together with the detailed prosopographical analysis of the governors of the town, their activities and relations with Constantinople and the local rulers from the inland Balkans – for which a strong need is felt – would certainly contribute significantly to the better understanding of Constantinople's policy in the regions which became the main ground for Byzantium's expansion in the Balkans / Europe after the destruction of Samuel's Bulgaria in 1018.

vaded the Byzantine mentality in the middle decades of the eleventh century all had their roots in that great victory, Constantinople had for centuries been waiting for, and in the awareness that the capital was now, finally, secure "from the back", from its European hinterland.

History knows of no clear breaks, and every division into different periods should be always treated with caution, understood conditionally as a device which provides a better means for presenting complex material. As far as Byzantium is concerned, the Byzantine twelfth century, in a way, already started with the accession of Alexios Komnenos in 1081, which led to a series of more or less systematic[9] changes in the Empire. As for the Empire's Balkan policy and its impact on Serbian history in particular, Alexios inherited the already existing system built in the course of the previous decades, the established channels of Byzantine direct or indirect influence, in short, a system he had to rely upon in the first years (if not decades) of his rule, confronted with the prospect of an imminent Norman attack on the Empire's European provinces and the region of Dyrrachium.

---

9    By this, it is not implied that all the changes undertaken during the long reign of Alexios Komnenos were carefully planned or always introduced with traceable and clear political and administrational intentions. The complex problem of the Comnenian system of governance, intertwined with the new social structure of the Empire based on the strong family hierarchy, has been analyzed many times in the last fifty years (from A. Hohlweg's *Beiträge zur Verwaltungsgeschichte des Oströmischen Reiches unter den Komnenen* [München, 1965], and P. Magdalino's now classic *The empire of Manuel I Komnenos 1143-1180* [Cambridge, 1993] to V. Stanković's, *Komnini u Carigradu [1057-1185]. Evolucija jedne vladarske porodice* [Belgrade, 2006], to name only a few), but all the consequences of the new political and social circumstances which prevailed in the Byzantium of the Komnenoi have not yet, however, received appropriate scholarly attention, especially the Empire's policy during the Comnenian century (1081-1180) in the lands within the Empire's sphere of dominance and/or influence (F. Makk, *The Arpads and the Comneni. Political Relations between Hungary and Byzantium in the 12th Century* [Budapest, 1989], is informative, but outdated). Similar principles were applied by the Comnenian emperors both in the East and in the West, with the establishment and strengthening of family connections with the local rulers which always formed the basis of the Empire's diplomacy, from the end of the eleventh century onwards. As far as the West – the Balkans – is concerned, the process started at the very beginning of the 12th century with the marriage of the heir to the throne John Komnenos (Alexios Komnenos' eldest son) and Piroshka (in Byzantium Irene) the daughter of the (then late) Hungarian king Ladislas, which cemented Constantinople's familial and political ties with Hungary and had its sequels at the end of the same century with the marriages of Isaac Angelos with the Hungarian princess Ekaterina and of Stephen, the son and (eventually) heir of Stephen Nemanja, with Eudokia, the daughter of the Alexis Angelos, probably in 1190 or soon after.

Thanks to a recently discovered seal of Constantine Bodin, we know a little more about the Byzantine system in the Balkans at the beginning of Alexios' reign, a system that was based on the hierarchical organization of the local rulers who were incorporated – at least nominally – into the Byzantine administrative system. To be clearer, Byzantium gave high-ranking titles and adequate administrative functions to the local leaders who executed power in their regions, thus incorporating them directly into the state bureaucracy and providing them with the prestige that accompanied the direct connection with the emperor in their own surroundings, among their possible rivals, a practice which must have been used for centuries by the Byzantine emperors.[10] Reflecting the importance of the Adriatic and Ionic coast for Byzantine interests and security, and especially mindful of the strength and the aspirations of the Normans who had conquered the Byzantine South Italy by 1071, the Byzantine defensive system in these areas – based always on local rulers – included the Doge of Venice, with the dignity of *protosebastos* and the 'function' of *dux of Croatia and Dalmatia,* and to the south of "his territories", Constantine Bodin, with the same lofty title of *protosebastos* and the 'function' of *eksousiastes of Diokleia and Serbia.*[11] At the southernmost end of this protective, defensive, military-administrative chain was the very important theme of Dyrrachium, whose significance is also confirmed by the high-profile personalities who were appointed as *duces* in the last decades of the eleventh century.[12]

In this way, thanks to the remarkable seal of Constantine Bodin and the data it offers, we can be certain that lands in Diokleia (roughly today's Montenegro), over which Bodin's ancestors ruled, but also the vast territories with unspecified borders to the north and the northeast of Diokleia that were named Serbia, belonged to the same state-like formation governed by Bodin. At the same time – again from the Byzantine point of view – we must conclude that Bodin's

---

10   Although not mentioning explicitly Byzantine dignities and titles, the practice is confirmed as early as the second half of the 9th century, when Basil I (not much later than 868) confirmed a local ruler in the Dalmatian inlands to be a kind of "first among the equals" (cf. B. Ferjančić, "Vasilije I i obnova vizantijske vlasti u IX veku," *Zbornik Radova Vizantološkog Instituta* 36 [1997], pp. 9-30), a practice that continued in one way or another for centuries, since we meet it again unambiguously in the mid-twelfth century under the emperor Manuel Komnenos; see, for example, a description of Manuel Komnenos' almost theatrical demonstration of dominance over Serbia in the years 1153-5 by "Prodromos" (Anonymous) Manganeios, ed. I. Rácz, *Bizánci Költemények Mánuel császár Magyar hadjáratairól* (Budapest, 1941), II (Manganeios no. 7).

11   J.-Cl. Cheynet, "La place de la Serbie dans la diplomatie Byzantine à la fin du XIe siècle," *Zbornik Radova Vizantološkog Iinstituta* 45 (2008), pp. 89-97.

12   P. Stephenson, *Byzantium's Balkan Frontier: A Political Study of the Northern Balkans 900-1204* (Cambridge, 2000), passim.

"lands", all the territories for which he was named governor-*eksousiastes*, formed a part of the Byzantine administrative system. They were regarded as such – as nominally Byzantine lands – in Constantinople, in the same manner as Bodin himself was regarded as a Byzantine bureaucrat, a highly positioned functionary in the imperial administrative hierarchy.

The significance of this new data cannot be overestimated, both regarding the new possibilities of explaining and comprehending some of the least known periods in early Serbian history, and concerning the necessity of being extremely cautious when drawing general conclusions that are based on very scarce source material. This statement acquires additional weight in view of the recent detailed research of the most problematic historical source which supposedly comprised the information about this period – the so called Chronicle of the Priest of Diokleia, or the Genealogy of Bar – which has perplexed scholars for generations with its incomprehensible stories. Allegedly beginning, in its original form, with the second part of the twelfth century, but as well describing earlier periods virtually unrecorded in any other source, the Chronicle of the Priest of Diokleia has always been considered a problematic, but partly reliable source which could provide some insight into the unknown history of the tenth to twelfth century Diokleia and Serbia, and their relations with Constantinople. This traditional attitude, which also symbolizes the inert character of modern historiography, was recently seriously challenged, and although one should not consider the entire issue closed, the possibility that the Chronicle of the Priest of Diokleia was nothing more than a later forgery, with no historical value for the reconstruction of the early history of Diocleia and Serbia, must be taken into account.[13]

To return to the seal of Constantine Bodin: the unusually high dignity of *protosebastos* that the ruler of Diokleia received from Constantinople is of especially great significance. In those times, *protosebastoi* belonged to the circle of the highest imperial dignitaries, and the Byzantine bearers of this title were always related to the Emperor. In the new hierarchy of the Komnenoi, the aristocracy was divided exactly along these lines, with *sebastoi* and *protosebastoi* above them, forming the inner circle of imperial dignitaries and aristocracy. When compared with the dignity of *protospatharos* which Bodin's father Michael, king of Diokleia, had received from the emperor Michael IV Paphlagonian, Bodin's title of *protosebastos* confirms a significant step forward for the rulers of Diokleia, with the equally important confirmation of their dominance over

---

13  S. Bujan, "La *Chronique du prêtre de Dioclée* un faux document historique," *Revue des études byzantins* 66 (2008), pp. 5-38. For a different opinion, see T. Živković in: *Gesta regum Sclavorum* II (Belgrade, 2009).

Serbia, which would soon take precedence over the coastal regions and become the new focus of Byzantine policy in the Balkans.[14]

## II.  Twelfth-Century Context: Stephen Nemanja and His Connections and Dealings with the Byzantine Empire

Half a century, from the last years of the eleventh century until the year 1149, when the Emperor Manuel undertook a punitive military action against the disloyal grand *zhupan* of Serbia Uroš, is shrouded in almost complete silence in Byzantine sources regarding the Byzantines' policy towards Serbia. And yet, it was precisely in this period that the new principles of mutual relations were firmly established and the models effectively introduced, on which Constantinople's dominance over the Serbian rulers was to rest for generations. Still, the indifference of Byzantine authors toward the Empire's activities in the Balkans inlands should not be solely attributed to their conscious disregard for Alexios Komnenos' and later his son's western policy or their disinterest in the insignificant Serbian principality. The lack of contemporary sources, in the first place contemporary historical works, is a conspicuous characteristic of the reigns of the first two Komnenoi, Alexios and John: The important, 25-year long reign of the latter is particularly problematic in this regard, with very scarce contemporary source material, the core of which are the poems of Theodore Prodromos.[15]

---

14  The seal of Constantine Bodin (regardless of whether it is dated immediately before or a little after the battle of Dyrrachium in October 1081, in which Bodin eventually did not take part, seeing the inescapable loss of the Byzantine army headed by the new emperor, Alexios Komnenos – at least that is the story that Anna Komnene tells us, *Alexias*, eds. D. R. Reinsch, A. Kambylis [Berlin-New York, 2001], IV, 5, 1- IV, 6, 9, especially pp. 135, 88-136, 96), points also to the evident and important division between Diokleia – a mostly coastal region in the southern Adriatic – and Serbia: a compound of territories gravitating to the most important regional center at that time, the castle-town of Ras in today's southwestern Serbia, near the present-day town Novi Pazar. Exactly in these territories, in Serbia proper, new and independent from Diokleia – but not without connections with it – a Serbian state would be born in the course of the first decades of the twelfth century.

15  This is not a place to analyze in more detail the vexed question of the character, variety and importance of Comnenian literary production and all the related problems. As far as the sources for John II's reign are concerned (1118-1143), from 1133 onwards Theodore Prodromos wrote a series of occasional poems that provide important information about the emperor's activities – which leaves Serbia (and Hungary) completely out of his focus, since John II's "Balkan campaigns" were finished by 1130, see W. Hörandner, *Theodoros Prodromos. Historische Geschichte* (Wien, 1974), pp. III sq. The case with Ma-

Despite the lack of source material, it is clear that a viable system of control and indirect governance over the Serbian territories was in effect during the reign of John II Komnenos (1118-1143), bringing with it the powerful Byzantine influence as well – a system the grounds for which were doubtlessly laid already during the decades of Alexios Komnenos' rule. This system must have been stable enough to allow the emperor to concentrate all his major military activities in the East, having secured the Balkan hinterlands by the 1130s. As far as we know, John Komnenos managed to obtain a favorable agreement with Hungary – his wife's motherland – and to keep the Serbian lands subjugated to the Empire through a system of electing or confirming the *grand zhupan* or *archzupan* who, in his turn, strengthened by Byzantine support, had effective control over the other *zhupanoi*. The relations between the Hungarian court and the Serbian 'ruling' family, which took a new direction with the marital agreement that occurred not long after the end of John II's campaigns and the establishment of peace between Byzantium and Hungary, should therefore not be viewed solely as the attempt of Serbia and Hungary to unite together against the 'common enemy' in Constantinople.[16] Since there are no indications about any hostile activities by the Serbian archzupans against the Empire for more than a decade and a half, until the turbulences caused by the Second Crusade, it seems plausible that the system established fully by John II Komnenos was functioning, and that bringing the Serbian and the Hungarian ruling families closer together may also have been encouraged, to put it mildly, by the emperor, since it helped consolidating the Byzantine influence in both countries. In any case, one should not forget that the quality of Byzantine relations with Hungary changed essentially with the marriage of the then heir to the imperial crown John Komnenos with Piroshka-Irene, whose son Manuel, half Hungarian by blood, went one step further in the attempt to dominate his mother's land.[17]

---

nuel's campaign against the Serbian archzhupan Uroš in 1149 would show that the Empire's Serbian policy was not unknown in the capital, and that the lack of more extensive historical works until the later part of Manuel's reign should not completely distort our picture of Constantinople's impact in Serbia and elsewhere, too. See, for example, Prodromos, ed. Hörandner, XXX, and Manganeios no. 26, in *Recueil des historiens des croisades, Historiens grecs* II, ed. E. Miller (Paris, 1881), pp. 761-763. The somewhat uncritical and almost exclusive reliance of modern scholarship on "Histories" is in any case too strong, methodologically outdated and unacceptable.

16  See, e. g. J. Kalić in: *Istorija srpskog naroda* I (envisaged as a handbook which should 'replace' Jireček's *Istorija Srba*) (Belgrade, 1981), pp. 197-211, especially p. 200.

17  Manuel's policy was, in general, more aggressive and more personal – those characteristics are applicable to his actions and attitudes both towards Hungary and towards Serbia, coming to the fore in the latter case especially in the emperor's close personal relations with Stephen Nemanja, cf. B. Ferjančić, "Stefan Nemanja u vizantijskoj politici druge

Although the system established by John Komnenos was doubtlessly in function in the years when Stephen Nemanja appears as the chief favorite of John II's son, Manuel, probably in the late 1150's, Nemanja's background, his 'special relations' with the emperor and his entire policy pose some important questions which until now have not been addressed adequately.

The personal history of Stephen Nemanja and, more generally, the history of Serbia of his time are widely unknown. This fact should be stressed from the outset when dealing with twelfth-century Byzantine-Serbian relations. Nemanja's unique position in Serbian medieval history, his place in later Serbian secular and church history and tradition as the sainted founder and patron saint of the dynasty, and the occasion that medieval Serbian original literary production starts with his two *Lives*, written by his sons St Sava and Stephen the First Crowned, make the task of determining the historical context in which his rise to power occurred in the second half of the twelfth century all the more difficult.

Before Stephen Nemanja appeared on the historical stage sometime at the beginning of the second half of the twelfth century, first as one of the four brothers governing the major part of Serbia, the system of Byzantine-Serbian relations established by John Komnenos was strengthened or even reformed and improved by his son Manuel. Confirming his dominance over the European hinterland of the Empire, especially over Hungary and Serbia in the aftermath of the Second Crusade, Manuel devoted unprecedented attention to establishing his direct control over the Serbian archzhupans. Given the emperor's entire policy and his personal character, it comes as no surprise that Manuel insisted, unlike his father or grandfather before him, on personally defeating his 'vassals' and on personally forcing the leaders who dared to rebel against his authority back into obedience. Taking personal relations to another level in Byzantine state policy and diplomacy, Manuel relied, and often had to rely, in the first place on his personal authority and dominance, bearing in mind the family circumstances of his accession to power.[18] Manuel had to build his authority within the Comnenian

---

polovine XII veka," *Stefan Nemanja – Sveti Simeon Mirotočivi. Istorija i predanje* (Belgrade, 2000), pp. 31-45; V. Stanković, *Manojlo Komnin, vizantijski car (1143-1180)* (Belgrade, 2008), pp. 219-230, 248-281.

18  In spite of the suddenness of Manuel's rise to power in the spring-summer of 1143, it seems that the change on the imperial throne had not affected Byzantine domination in the Balkans and that there was not a single noteworthy reaction to the death of the emperor John Komnenos. Without doubt, it was a consequence of the firm and stable dominance of the Empire in this region and another testimony that John II Komnenos had already established a functioning system of Byzantine influence and that for the entire decade, from 1133 onwards, he felt secure enough from the "West" and "North" to campaign continuously in the East, sometimes taking with him all his four sons, like he did

family in the first place, and that is true especially for the first decade of his reign (1143-1153) – exactly at the time when his first expedition against the disobedient Serbian archzhupan Uroš II took place, in the years 1149 and 1150.

Manuel Komnenos used the punitive campaign in 1149 and especially its sequel in 1150 to demonstrate his personal dominance over Serbia and, in a lesser degree, over Hungary as well. It was his first action in the Balkans since he had become emperor six years earlier. It was Manuel's chance to position himself as the absolute overlord in the Empire's European hinterland, and he seized the opportunity and made his point with emphasis: Times had changed and, unlike his father, he intended to execute his suzerain rights in a new, flamboyant, even theatrical fashion. These rights included the more active role of the emperor in deciding about the candidates for the leading positions in the regions under the emperor's dominance. Manuel had openly introduced the system of imperial favorites in Byzantine foreign policy and diplomacy in a manner that his predecessors could not have achieved, even if they had tried.

It was within this system that Stephen Nemanja rose to be one of the emperor Manuel's favorites in Serbia in the late 1150s, becoming the archzhupan in

---

on that last and fatal expedition of the years 1142-1143. It should not be forgotten, after all, that by the year 1143 the Comnenian system of governing the Empire, based on strong familial relations and connections with all the significant personalities, had long since surpassed 'the internal political borders' and spread throughout Europe, building up on marriages especially of John II's four sons with foreign princesses. We should also bear in mind that the Byzantine influence, which would enable Manuel's ambitious world policy, was by far stronger and deeper than can be confirmed from the information in the existing sources. On the other hand, the hierarchically structured state apparatus, naturally comprising the church hierarchy as well, with relatives positioned within it according to their (blood) proximity to the emperor, makes the fact that Manuel's 'uncle' Adrian, as monk John (John II's first cousin, son of the Sebastokrator Isaak, the elder brother of the emperor Alexios I) was Archbishop of Ohrid from ca. 1139/1140 onwards all the more significant for the Comnenian family connections between Constantinople and the Balkans, the quality of the Empire's influence in these regions, and especially for the level of knowledge and comprehension that the emperor in Constantinople could have had about the political development in the Balkans, the major personalities, and rival families. J. Kalić, "Srpska drzava i Ohridska arhiepiskopija u XII veku," *Zbornik Radova Vizantološkog Instituta* 44 (2007), pp. 197-208, although offering some interesting observations, and generally placing the Byzantine influence in Serbia through the Archbishopric of Ohrid in its correct context, suffers from the usual flaws – the insufficiently exact historical context in which the individual information and events are placed and an adherence to the common views and the corpus of frequently used sources. S. Ćirković, "Problemi biografije svetoga Save," *Rastko Nemanjić – Sveti Sava. Istorija i predanje* (Belgrade, 1979), pp. 7-12, rightfully underlines some of the constant problems of Serbian medieval historiography and, especially, of scholars' methodological approach to analysis of the Serbian medieval sources.

the middle years of the following decade, doubtlessly with the help of his powerful imperial patron from Constantinople. Nemanja's three-decade long rule as grand zhupan significantly changed the position of Serbia and strengthened the internal cohesion of the country, but, at the same time, connected it decisively with Byzantium, both politically and religiously. His long rule and the fact that Serbian medieval historiography starts with his two biographies had as a side effect an uncertainty regarding his policy toward the Empire, in a time when Byzantium had undergone a series of changes which led to a diminishing of its power and, eventually, to the destruction of the Empire with the capture of Constantinople by the Crusaders in 1204. There should be no doubt, however, that Nemanja, like his sons Sava and Stephen, belonged completely to the Byzantine world and was understood as such by the Byzantines themselves.[19] Nemanja's 'national' policy and the creation of a 'national' ideology, which was to remain the basis of the Serbian medieval state, stood in no contradiction to his conscious pro-Byzantine choices to which he adhered all his life.

Once the protégé of the mighty emperor Manuel Komnenos, who had bestowed on him some unspecified imperial title, Nemanja's decision to leave his 'throne' to his second son, at that time the son-in-law of the new emperor Alexios III Angelos, determined the path of his descendants' state and cemented its close connections with the Byzantine emperors and the Byzantine world in general. Nemanja's heir Stephen had received the exalted title of *sebastokrator*, surely in the years between 1190 and 1195, maybe exactly in 1195, with the rise to the imperial throne of his father-in-law, Alexios Angelos, which left no doubt that the ruler of Serbia[20] belonged to the highest strata of the *Byzantine aristocracy* and, even more importantly, to the emperor's closest circle.

---

19  See the act of the emperor Alexios III Angelos from the year 1198, *Actes de Chilandar I. Des origins à 1319*, eds. M Živojinović, V. Kravari and Ch. Giros (Paris, 1988), no. 4, pp. 107-109, and for Nemanja's sons, the acts of Demetrios Chomatenos, the Archbishop of Ohrid, *Demetrii Chomateni Ponemata diaphora*, ed. G. Prinzing (Berlin-New York, 2002), nos. 1, 10, 13, 86.

20  Stephen is intituled as archzhupan of Serbia and Diokleia (Τῷ πανευγενεστάτῳ μεγάλῳ ζουπάνῳ πάσης Σερβίας καὶ Διοκλείας, ἐν Κυρίῳ ἀγαπητῷ ἡμῖν τέκνῳ, κυρῷ Στεφάνῳ τῷ Νεεμάνῃ) in the act no. 10 ed. Prinzing of Demetrios Chomatenos, which resembles (always from the Byzantine point of view) the title of Constantine Bodin from the end of the eleventh century as governor of Diokleia and Serbia.

## III.  Thirteenth-Century Context: King Uroš I and His Relations with the "Byzantine World" before and after 1261

After the Byzantine catastrophe of 1204, Serbia searched for its place in the new world order between the Byzantine states of Nikaia and Epirus, Hungary, Bulgaria and the Crusaders' states which were founded on the former Byzantine territories in Europe. In completely new political surroundings and changed circumstances, King Uroš I (1243-1276) was forced to try and lead a balanced policy, especially in view of the political weight that his wife, Queen Jelena, who was of western, most probably of Hungarian origin, was carrying.[21]

King Uroš is usually perceived as a pro-Western, or anti-Byzantine ruler, and yet he was the first Serbian ruler to be portrayed exactly like the Byzantine emperor on the walls of his foundation, the Trinity church in the Sopoćani monastery, marking a clear distinction with the ways his brothers were portrayed just a couple of decades earlier.[22]

The reasons for the strong belief that King Uroš harbored evident anti-Byzantine attitudes are based mostly on two short episodes of his dealings with the Byzantines, from the year 1257 and from circa 1268, conveyed by George Akropolites and George Pachymeres respectively. The first author, George Akropolites, describes King Uroš's attacks on the Byzantine territories, i. e. on the territories of the Nicean Empire around Prilep and Skopje in 1257, and his alliance with the *despot* of Epirus Michael II. Akropolites, who was the commander of the besieged fortress of Prilep, paints a vivid, negative picture of the Serbian king Uroš I. Being the only source that mentions the Serbian king and his activities in those years, his account has been used as proof of Uroš's *constant* anti-Byzantine attitudes and actions.

George Pachymeres, on the other hand, is the only source that mentions the attempts to arrange a political and marriage alliance between Serbia and Byzantium in the years1269-1270, when the emperor Michael VIII Palaiologos betrothed his daughter Anna to Uroš's younger son, the prince and later king Milutin. According to Pachymeres' almost unanimously accepted version, it was the Serbian part, and King Uroš I in particular, who canceled the planned mar-

---

21  G. L. McDaniel, "On Hungarian-Serbian Relations in the Thirteenth Century: John Angelos and Queen Jelena," *Ungarn Jahrbuch* 12 (1982-3), pp. 43-50.

22  S. Ćirković gives a balanced picture and by far the best assessment of the long reign of the king Uroš in *Istorija srpskog naroda* I (Belgrade, 1981), pp. 341-356. B. Ferjančić, "Srbija i vizantijski svet u prvoj polovini XIII veka (1204-1261)," *Zbornik Radova Vizantološkog Instituta* 27-28 (1989) pp. 104-148, remains the most valuable original research of this period after Jireček. Ferjančić's paper is cited frequently, but the results of his research are, surprisingly, not used adequately or in a measure they deserve.

riage and who had blocked the stronger Byzantine influence in Serbia and chose instead to forge a closer alliance with Hungary.[23]

There is, however, sufficient evidence *in Byzantine sources* themselves that allows for different explanations regarding both of the aforesaid episodes. In one passage of the funerary oration to the emperor John Vatatzes by George Akropolites, written in 1254/5 – that has surprisingly completely escaped the attention of scholars[24] –, the author describes the Serbian king Uroš as a *servant* (*doulos*) of the late emperor, who also had the obligation to send auxiliary troops, in the same way as his predecessors had done a century ago. Akropolites hints between the lines at Uroš's possible disloyalty to the successor of Vatatzes, a theme that he would develop in his historical work when describing the events of 1257.

The close ties of the king Uroš and the emperor John Vatatzes, which are now ascertained, raise many questions, stressing once again the relativity of our knowledge. Akropoltes' information sheds a completely new light on the complex situation in southeastern Europe in the mid-thirteenth century, provoking new ways of looking at Serbia's connections with the empire of Nicaea and its influence on the development of the Serbian dynasty. That being said, one should not forget that Uroš had become the Serbian king in 1243 under circumstances that are completely unknown. His rise to the throne occurred in the years that immediately followed the death of the Bulgarian tsar John II Asen, at the

---

23  Georges Pachymérès *Relations historiques* II, ed. A. Failler (Paris, 1984), V. 6, pp. 453-457. Translation in Serbian of the major part of this story and commentary by Lj. Maksimović, *Vizantijski izvori za istoriju naroda Jugoslavije* VI (Belgrade, 1986), pp. 22-30. Idem, "L' idéologie du souverain dans l' État serbe et la construction de Studenica," *Studenica i vizantijska umetnost oko 1200. godine*, ed. V. Korać (Belgrade, 1988), pp. 35-49, and "Byzantinische Herrscherideologie und Regierungsmethoden im Falle Serbien. Ein Beitrag zum Verständnis des byzantinischen Commonwealth," *ΠΟΛΥΠΛΕΥΡΟΣ ΝΟΥΣ. Miscellanea für Peter Schreiner zu seinem 60. Geburtstag* (München-Leipzig, 2000), pp. 174-192, presents in broad lines correct elements of the relations between the Byzantine world and Serbia, but remains too general and unspecific. For a recent detailed analysis, see V. Stanković, *Kralj Milutin (1282-1321)* (Belgrade, 2012), pp. 32-50.

24  Georgii Acropolitae *Opera* II, ed. A. Heisenberg (Leipzig, 1903) (= editionem anni MCMIII correctionem curavit P. Wirth [Stuttgart, 1978]), pp. 18, 25-28. I suspect that the main reason for the absolute oversight of this passage over the generations of scholars is the fact that it is not mentioned in the handbook by Jireček, *Istorija Srba*, p. 177, especially when compared with the constant repetition of similar information from a letter by Theodore II Laskaris, that Jireček quotes in that place, cf. V. Stanković, "Bugarska i Srbija u delima Georgija Akropolita i Georgija Pahimera," *Zbornik Radova Vizantološkog Instituta* 46 (2009), pp. 179-200.

time when the emperor of Nicaea, John Vatatzes, was leading his great and successful offensive in Europe.

Regarding the engagement between the Serbian prince Milutin and Anna Palaiologina from 1269-1270., both Pachymeres and Theodore Methochites in his *Presbeutikos logos*,[25] his description of the negotiations with King Milutin in 1299 that ended with his marriage to the little Symonis, indicate clearly enough that it had been *the Byzantine side* which had canceled the marriage plans.[26] One of the conceivable reasons, mentioned *en passant* by George Pachymeres himself,[27] could have been the failure of the Byzantine negotiators to make sure that the emperor's future son-in-law, then Prince Milutin, would become the successor to the throne and thus the promoter of Byzantine interests in Serbia in the volatile times preceding and following the union of churches in Lyon in 1274. In different circumstances three decades later, King Milutin (1282-1321) did manage to marry a daughter of the emperor – this time insisting on marrying the five-year-old Symonis, despite her young age –, thereby confirming once more the importance of relations with Byzantium and the imperial family for the internal development of the Serbian state.

## Conclusion

In summing up, I wish to stress that the Byzantine influence was not the only influence that contributed to the development of the Serbian medieval state and its ideology, but it was without doubt the most important one. Leaving aside the assumption of political 'independence' that medieval Serbia obtained during the time of Stephen Nemanja, which has often been put forward in historiography, as a complete anachronism that is not acceptable in the context of twelfth-century history, we should return to the vision that the founder of the Serbian medieval dynasty, Nemanja himself, expressed regarding his own and the position of Serbia in the Christian world. In the highly peculiar founding charter of the Chilandar monastery on Mount Athos, which he issued under his secular name although he had become a monk and had retired from power two years earlier, Nemanja said that *God made Greeks the emperors, Hungarians the kings, and himself appointed as the grand zhupan*, confirming in the clearest possible way that the acceptance of Byzantine influences was his conscious po-

---

25  L. Mavromatis, *La fondation de l'empire serbe. Le kralj Milutin* (Thessalonica, 1978), lines 649-661.

26  Understood correctly already by Ivan Djurić in his commentary of the Presbeutikos logos, *Vizantijski izvori za istoriju naroda Jugoslavije* VI (Belgrade, 1986), p. 134.

27  Pachymérès ed. Failler, II/V.6, 455, pp. 16-17.

litical decision and, also, that Byzantine political theory was perfectly well understood in Serbia at the end of the twelfth century.

Lastly, I believe that the proper way to finish this paper, that has perhaps raised far more questions than it was able to answer, is to propose ways for further research, in order to acquire a better understanding of the Byzantine influence in Serbia and, consequently, the development of the Serbian medieval state. The first step, in any case, should be to reexamine and reevaluate the literary sources, both Byzantine and Serbian, by means of detailed historical, philological and literary analyses that will enable us to interpret their data more adequately and more correctly. As far as the Serbian sources are concerned, we still lack even critical editions of the most important texts, as is the case with the Lives of St Sava and St Symeon by the monk Domentian, written around the middle of the thirteenth century, whose learned style and complex narration should be studied in detail from the literary perspective as well as from the historical point of view, instead of simply accepting some of his information and discarding other, in a circular argumentation that allows for provisional solutions in the selection of reliable 'facts' and for misinterpretations of this unique and extremely valuable source.[28] The next step should be a comparative approach to the historical circumstances that preceded and followed the studied period and events, which will take into account the results of similar studies both from the domain of Byzantine Studies and the western Medieval Studies.

Moreover, it is my strong conviction that only through detailed studies of each individual case shall we be able to create a more accurate and more detailed overall picture of the relations between Serbia and Byzantium, and that only when every single piece of evidence is placed in its correct historical context we can avoid generalizations that are based more on assumptions than on the firmly established characteristics of the studied period.

---

28  Lj. Juhas-Georgijevska, *Život svetog Save od Domentijana. Istorija teksta* (Belgrade, 2003), brings us, unfortunately, not an inch closer to solving the many difficulties regarding Domentian's text, its structure, date of composition and contents, or the author's intentions; S. Ćirković, "Domentijanova prosopografija," *Zbornik Radova Vizantološkog Instituta* 45 (2008), pp. 141-155, analyzes Domentian's work, and suggests that Sava may have obtained the autocephaly for the Serbian church from Nicaea already in 1218.

# The Contributors

*Slobodan Ćurčić* is Professor Emeritus at Princeton University. His research centers on late antique and Byzantine architecture and art. Recent publications include the comprehensive monograph *Architecture in the Balkans from Diocletian to Süleyman the Magnificent* (New Haven and London, 2010) and *Architecture as Icon. Perception and Representation of Architecture in Byzantine Art* (New Haven and London, 2010), which he edited together with Evangelia Hadjitryphonos.

*Jelena Erdeljan* is assistant professor at the Department of Art History at the University of Belgrade. She specializes in Byzantine and Medieval Art and has researched phenomena and patterns of cultural exchange in the medieval Balkans. Recent publications include: *Jewish Funerary Monuments from Niš: A Comparative Analysis of Form and Iconography*, El Prezente. Studies in Sephardic Culture, Vol. 4 (Dec. 2010), pp. 213-232; *New Jerusalems as New Constantinoples? Reflections on the Reasons and Principles of Translatio Constantinopoleos*, Slavia Orthodoxa, ΔΧΑΕ 32 (2011), pp. 11-18; *Studenica. All Things Constantinopolitan*, ΣΥΜΜΕΙΚΤΑ, Collection of Papers in Honor of the 40th Anniversary of the Institute for Art History, Faculty of Philosophy, University of Belgrade, ed. by I. Stevović and J. Erdeljan (Belgrade, 2012), pp. 93-101.

*Vujadin Ivanišević* is a department member of the Archaeological Institute in Belgrade. His scholarly work is devoted to Medieval Archaeology, Late Antique and Byzantine Studies and Numismatics. He is the author of *Les trésors monétaires byzantins des Balkans et d'Asie Mineure (491-713)* (Paris, 2006) and has recently published the monograph *The Pontic-Danubian Realm in the Period of the Great Migration* (Paris, 2012).

*Čedomila Marinković* teaches at the Faculty of Dramatic Arts in Belgrade. Her research is centered on architectural imagery in Byzantine art and architecture. Recent publications include: *Founder's Model – Representation of a Maquette or the Church?*, Zbornik Radova Vizantološkog Instituta 44/1 (2007), pp. 145-153; *A Live Craft: The Architectural Drawings on the Façade of the Church of the Holy Virgin in Studenica (Serbia) and the Architectural Model from Cerven*

*(Bulgaria),* Proceedings of the III AIMOS seminar (Thessalonica, 2008), pp. 52-63; *The Representation of Architecture on the Donor Portrait in Lesnovo*, Macedonian Historical Review (Skopje, 2011), pp. 103-113.

*Vlada Stanković* is associate professor of Byzantine Studies at the University of Belgrade. Since 2011, he heads the project *Christian Culture in the Balkans in the Middle Ages: The Byzantine Empire, the Serbs and the Bulgarians from the 9th to the 15th Century.* He has organized the international symposium *Before and after the Fall of Constantinople. The Center and Peripheries of Byzantine World in the Turbulent Times before and after the Conquests of Constantinople in 1204 and 1453* (Belgrade, 2012). His publications include the monographs: *The Patriarchs of Constantinople and the Emperors of the Macedonian Dynasty* (Belgrade, 2003); *The Komnenoi in Constantinople (1057-1185). The Evolution of a Ruling Family* (Belgrade, 2006); *Manuel I Komnenos, Byzantine Emperor (1143-1180). A Biography* (Belgrade, 2008); *King Milutin* (Belgrade, 2012).

## Studien und Texte zur Byzantinistik

Band 1 Heinz Gauer: Texte zum byzantinischen Bilderstreit. Der Synodalbrief der drei Patriarchen des Ostens von 836 und seine Verwandlung in sieben Jahrhunderten. 1994.

Band 2 Andreas Külzer: Peregrinatio graeca in Terram Sanctam. Studien zu Pilgerführern und Reisebeschreibungen über Syrien, Palästina und den Sinai aus byzantinischer und meta-byzantinischer Zeit. 1994.

Band 3 Cordula Scholz: Graecia Sacra. Studien zur Kultur des mittelalterlichen Griechenland im Spiegel hagiographischer Quellen. 1997.

Band 4 Michael Altripp: Die Prothesis und ihre Bildausstattung in Byzanz unter besonderer Be-rücksichtigung der Denkmäler Griechenlands. 1998.

Band 5 Dariusz Brodka: Die Geschichtsphilosophie in der spätantiken Historiographie. Studien zu Prokopios von Kaisareia, Agathias von Myrina und Theophylaktos Simokattes. 2004.

Band 6 Svetlana Bliznyuk: Die Genuesen auf Zypern. Ende 14. und im 15. Jahrhundert. Publika-tion von Dokumenten aus dem Archivio Segreto in Genua. 2004.

Band 7 Christiana I. Demetriou: Spätbyzantinische Kirchenmusik im Spiegel der zypriotischen Handschriftentradition. Studien zum Machairas Kalophonon Sticherarion A4. 2007.

Band 8 Mabi Angar / Claudia Sode (eds.): Serbia and Byzantium. Proceedings of the International Conference Held on 15 December 2008 at the University of Cologne. 2013.

www.peterlang.com